MOUNTAIN GOATS
OF
GLACIER
NATIONAL PARK

PHOTOGRAPHY AND
INTRODUCTION BY

SUMIO HARADA

TEXT BY KATHLEEN YALE

FARCOUNTRY
PRESS

RIGHT: In spring, goats shed their heavy coats.

FACING PAGE: A distinguished female levels her gaze.

TITLE PAGE: Curious goats peer down from their rocky perches.

FRONT COVER: Two female goats stand close together.

BACK COVER: A lone male surveys his craggy domain.

Many thanks to Kathleen Yale for text contributions to this project.

Kathleen Yale left her heart in Glacier National Park after spending her first season there eight years ago. She has spent the last several years working as a wildlife field biologist and freelance writer in various Montana locales, most recently in Yellowstone National Park. Her essays and poems have appeared in assorted journals and anthologies.

ISBN 10: 1-56037-472-1
ISBN 13: 978-1-56037-472-5

© 2008 by Farcountry Press
Photography © 2008 by Sumio Harada
Text by Kathleen Yale
Translation of introduction by Moyu Sato Harada

For more information about our books, write Farcountry Press, P.O. Box 5630, Helena, MT 59604; call (800) 821-3874; or visit www.farcountrypress.com.

Created, produced, and designed in the United States.
Printed in China.

16 15 14 13 12 2 3 4 5 6

INTRODUCTION

By Sumio Harada

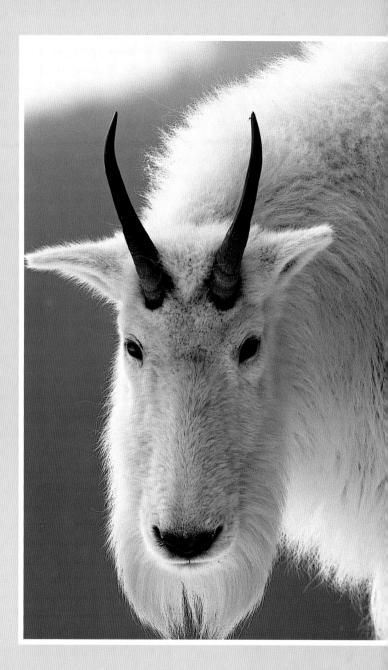

In 1994, my family and I left our home in Japan and moved to West Glacier, Montana. Our purpose was to allow me the opportunity to photograph the mountain goats of the northern Rocky Mountains, specifically Glacier National Park, one of the most spectacular places in the world.

My wife and I struggled with the decision to move our family to another country—to separate our daughter, then four years old, from her grandparents, her friends, and the world she knew and raise her in the United States.

Why would I put my family through all this for mountain goats? It's a question I frequently ask myself, and I struggle with the answer to this day. All I'm certain of is that these beautiful, agile creatures that populate the remote recesses of Glacier National Park leave me awestruck; they are my favorite photographic subject.

During the summer, mountain goats frequently visit Logan Pass, much to the pleasure of Park visitors traveling the Going-to-the-Sun Road. Although the mountain goats seem to tolerate tourists and appear almost domesticated, they are indeed wild animals. They come to Logan Pass for the plentiful alpine vegetation and because predators—grizzly bears and coyotes—are few due to the presence of people. The mountain goats at Logan Pass are so accustomed to humans that they seem to hardly notice the crowds of people bustling about. They simply go about their business of grazing on the abundant vegetation in the warm summer sun.

In contrast, winter in Glacier National Park is frigid and harsh, and life for the mountain goats is not easy. In search of scarce food, the mountain goats head for the rugged ridges, where the wind has blown away the snow and uncovered small amounts of dry vegetation. Avalanches take the lives of

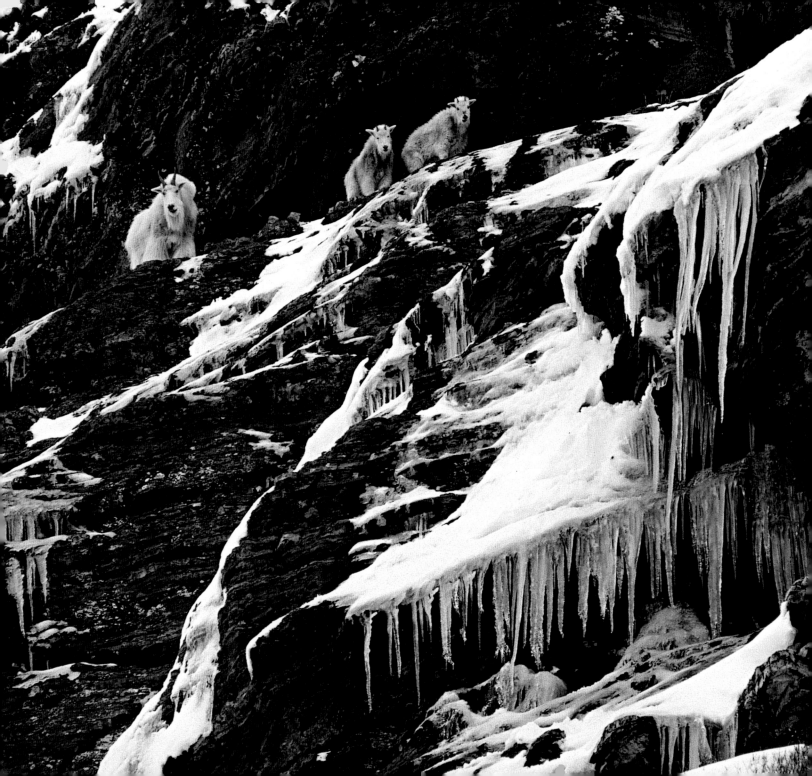

some goats, and starvation is always a looming threat. Yet, these adaptable creatures have managed to thrive in the Park's extreme conditions.

Even during the most severe winters, mountain goats stick to their range at timberline or in the higher alpine regions; they will not descend to lower ground. With the current warming of the Earth's temperatures, there has been a notable decrease in alpine range, and what range is left is no longer connected but rather separated into "islands." This leads not only to a reduction in the goat population, but to poor genetic variation.

Global climate change has impacted life for the mountain goats in the summer as well. During the heat of day, the goats cool off by lying on the snow-banks that have not yet melted, a critical behavior that keeps them from overheating. Over the last twenty years, however, snowbanks have been melt-ing away earlier than in previous years. This melting is most obvious when looking at the Park's glaciers. In 1850 there were more than 150 glaciers; as of press time, there are 27. At the present rate of melting, the glaciers will be completely gone by 2030.

On a personal level I am inspired by the mountain goats' resiliency, and as a wildlife photographer I am fascinated by how their bodies have adapted to their rugged environment. Because goats reside on steep cliffs to evade predators, they have developed short legs for easy climbing, and their hooves have soft pads in the center for increased traction. The flexible joints in their muscular shoulders make them expert climb-ers, and their narrow bodies allow them to balance on precarious ledges. They have a double coat of fur—an undercoat of dense, fine wool combined with a coat of coarse, hollow guard hairs—to protect them from frigid temperatures.

Unlike mountain goats, photographers have not evolved to thrive in the extreme environments of Glacier National Park. One winter day I climbed a slope in the Many Glacier area to photograph goats. Bracing wind struck me from all directions. I lowered myself to the ground, but the wind was so strong that I thought it might lift me off the mountain. I had to turn away from the wind because it took my breath away, and I had to wear sunglasses to keep the snow from burning my eyes.

The wind calmed slightly, and I managed to col-lect and set up my equipment just as the mountain goats began to gather. A sudden gust knocked me over, and my camera and tripod followed. I slid about ten feet down the snow-covered ridge, scraping and bruising my arms and legs, and breaking the lens I was wearing around my neck.

Although most of my time photographing goats hasn't been quite that dramatic, there is always peril when I'm entering their realm. These experiences have humbled me and fed my respect for the sure-footed and adaptable animals.

This book showcases the best of my mountain goat images, the result of nearly twenty years photograph-ing in Glacier National Park. I am thrilled to share these photographs with you.

I dedicate this book to my wife, Kumi, and my daughter, Moyu, who have shown me great love and support, and who have stood by me in my quest to capture these remarkable mountain goats on film.

FACING PAGE: May's snowmelt freezes into thick cicles that adorn the mountain goats' favorite haunts.

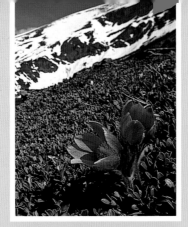

In 1910, Glacier became the country's tenth national park. Encompassing more than 1 million acres of the scenic northern Rocky Mountains ecosystem in northwestern Montana, Glacier National Park is home to a host of native flora and fauna, including a number of large mammals. Wolves, bears, lynx, mountain lions, elk, bighorn sheep, and cliff-loving mountain goats all live in the Park.

Mountain goats inhabit rocky, alpine territory and are the largest mammals that regularly live at altitudes up to 10,000 feet. The Park's glacier-carved terrain and signature peaks and precipices provide the ideal habitat for these alpinist ungulates, and their iconic white forms can often be seen dotting the distant cliffs throughout the year.

Male and female goats, (called billies and nannies, respectively) are much alike in appearance. Both have sharply pointed black horns that are roughly equal in length, twelve inches, though female horns are

SPRING

thinner at the base and are less curved than male horns. A goat's horns continue to grow throughout its lifetime, and an individual's age can be determined by counting the horns' annual growth rings. The average adult billy weighs between 180 and 250 pounds, and nannies generally weigh from 125 to 170 pounds.

Spring is the birthing season. Just as the first yellow glacier lilies peek out from receding snowlines in late May or early June, nannies separate themselves from other goats and find isolated ledges to deliver their young, called kids. Birth time is synchronized among the females, and most kids are born within a two-week period. Nannies and newborns remain in the birth area for a few days, until the kids are able to follow their mothers over the rocky terrain. Soon they meet up with other nannies and kids and start migrating toward the sun-dappled mountain meadows lush with tasty wildflowers.

ABOVE: Delicate pasque flowers are some of Glacier's first wildflowers to appear in spring.

RIGHT: Snow shelves break apart and slide into Iceberg Lake as a lone traveler crosses the thinning ice. In the summer months, icebergs often remain floating in the lake, which is located near Many Glacier.

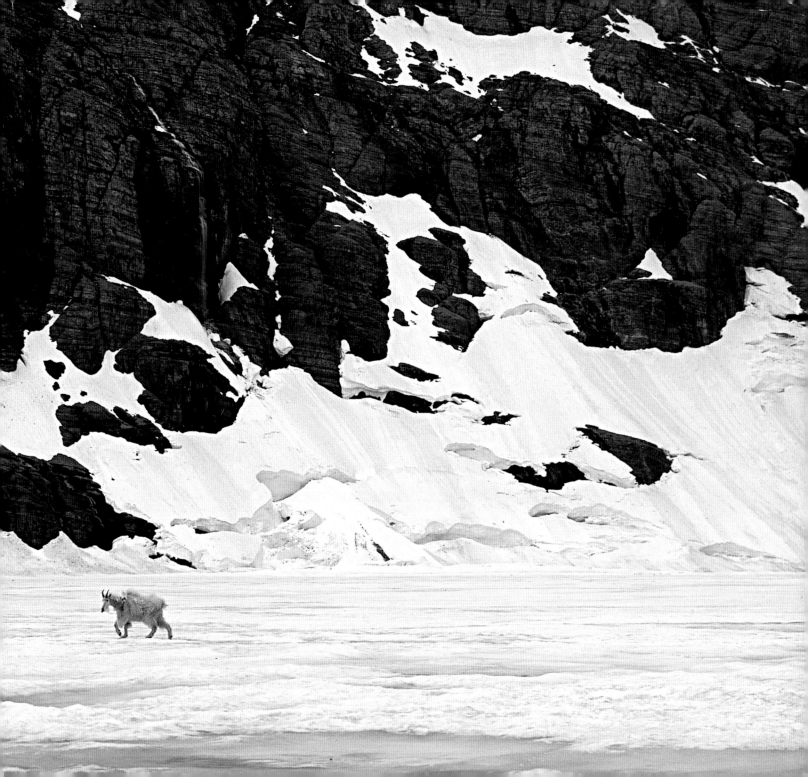

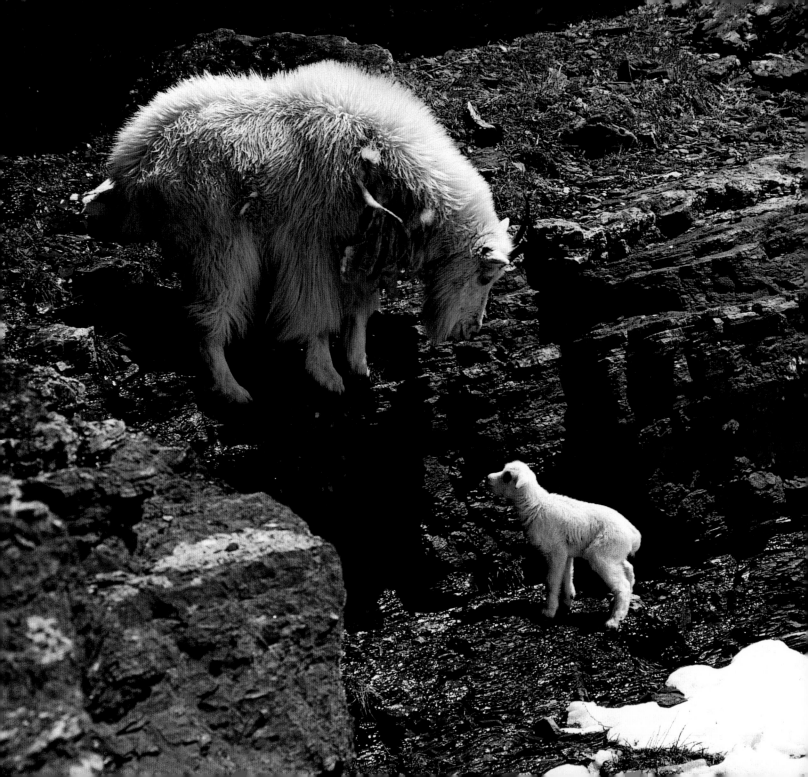

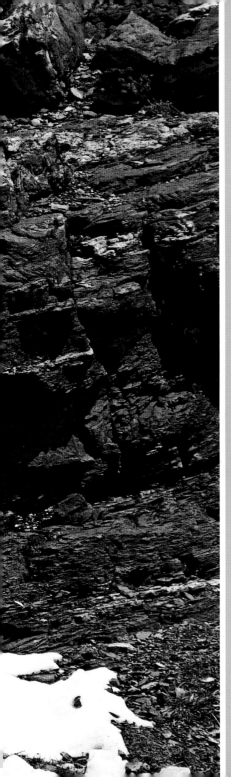

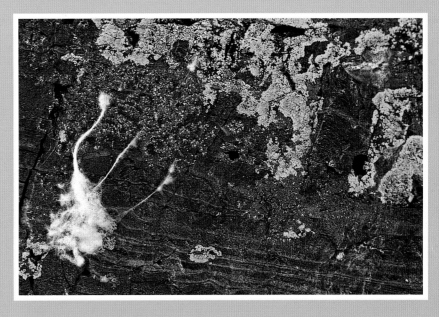

ABOVE: A clump of hair adorns a lichen-flecked boulder. Mountain goats shed their thick winter coats throughout the spring and summer months, inadvertently decorating their rocky haunts with tufts of soft white.

LEFT: When ready to give birth, nannies leave their small herds to seek the solitude and safety of secluded ledges. Their young, called kids, are born between late May and early June and begin to practice climbing just hours after birth. Nannies usually have just one kid; twins are rare.

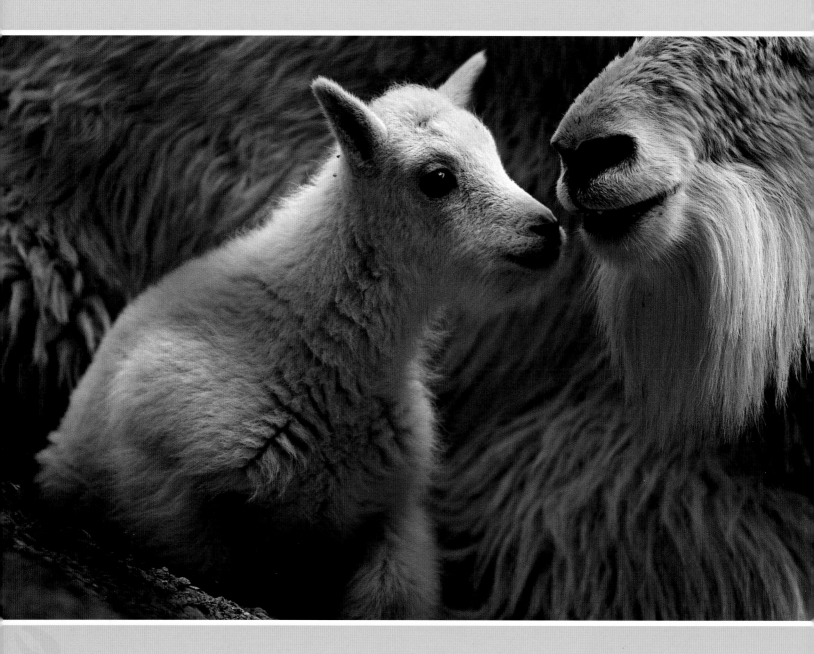

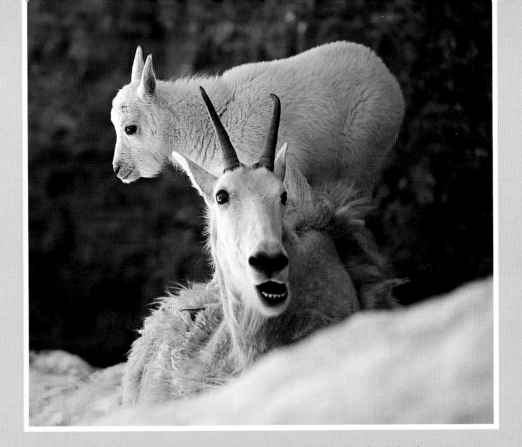

ABOVE: A kid practices climbing the small mountain of its mother's back.

FACING PAGE: Unlike deer or elk mothers, nannies do not stash their young and forage alone but rather keep them close at all times. Precocious kids start to dabble in grazing several days after birth; they continue to nurse throughout the summer before switching to an entirely herbaceous diet. Goats are generalist grazers; they eat whatever plants are available, often alternating between alpine grasses and sedges, and also browse on shrub leaves, twigs, and conifer needles.

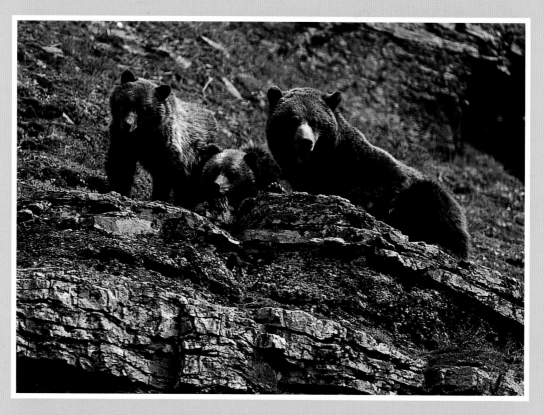

ABOVE: A sow grizzly bear and her two cubs take a break from foraging. Although grizzly bears are formidable predators, they pose virtually no threat to cliff-dwelling mountain goats, which can easily out-climb them.

FACING PAGE: Goats, for the most part, remain safe from would-be predators by living in rugged, isolated territories. Nannies must keep an eye out for golden eagles, however, which occasionally snatch up newborn kids.

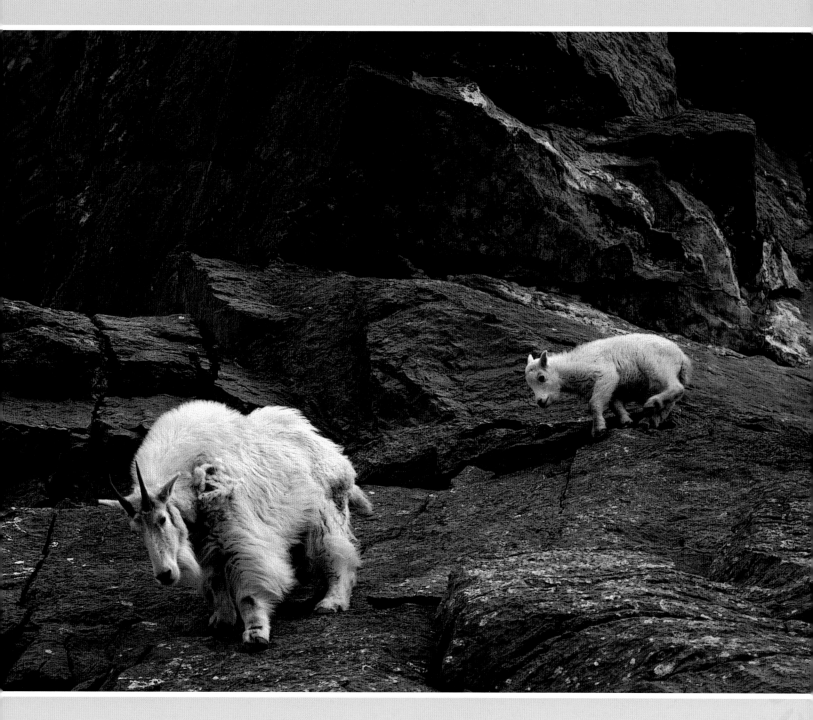

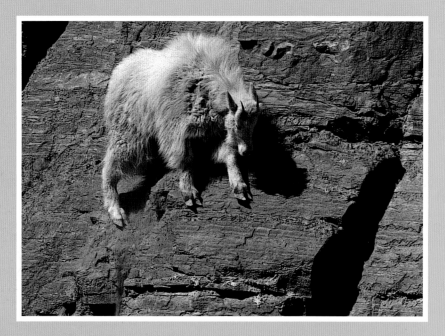

ABOVE: A natural-born rock climber. The mountain goat's split hooves are well adapted to rocky terrain. Sharp outer rims and flexible, rubbery soles allow the animals to securely grip even the smallest of footholds.

RIGHT: These four-week-old kids have no trouble keeping up with their mothers. Just a few days after birth, kids are surefooted enough to follow their mothers anywhere. Nannies and their kids reassemble into matriarchal nursery herds that stick together throughout the summer.

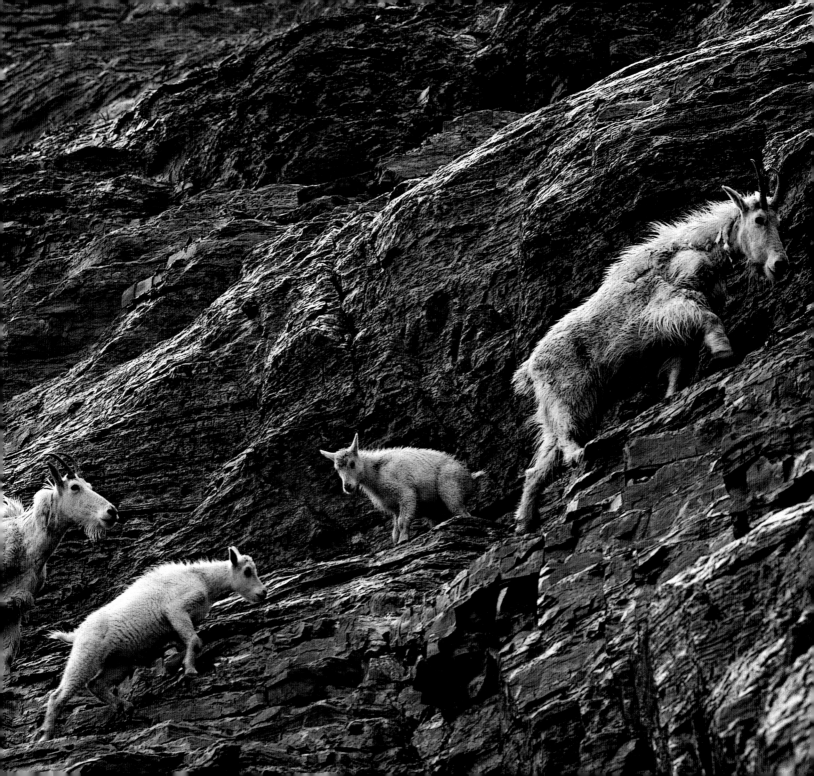

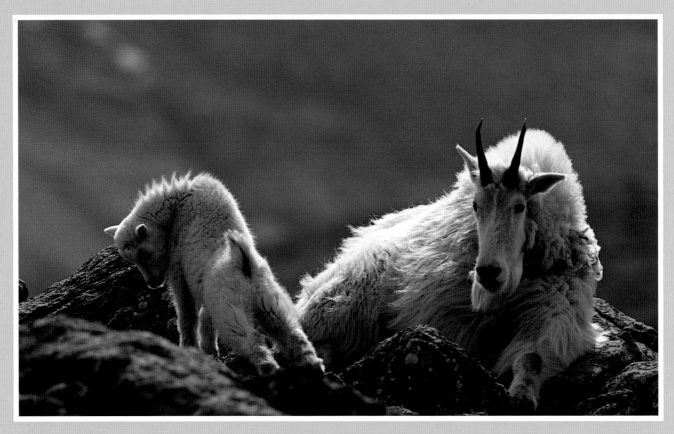

ABOVE: A kid stretches before joining its mother for some rest. Mother goats raise their young without aid from adult males. Kids stay with their mothers for one year, until the next year's kids are born.

FACING PAGE: A curious kid tests his climbing abilities.

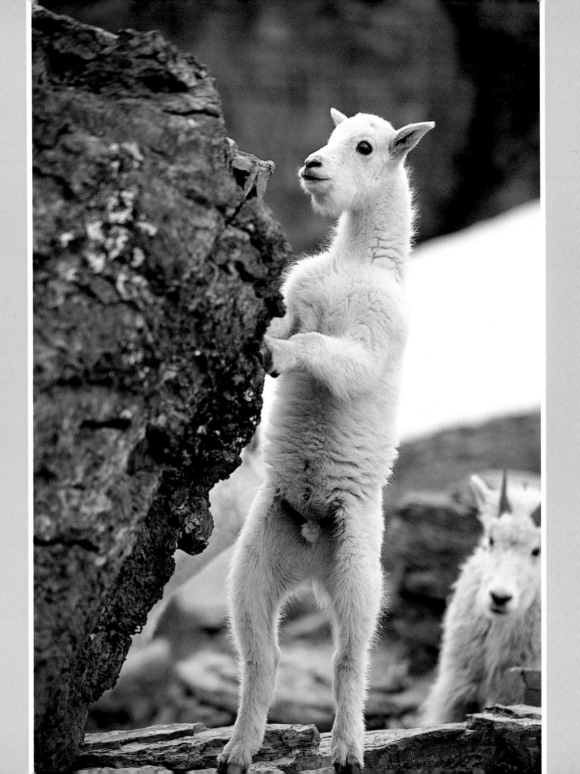

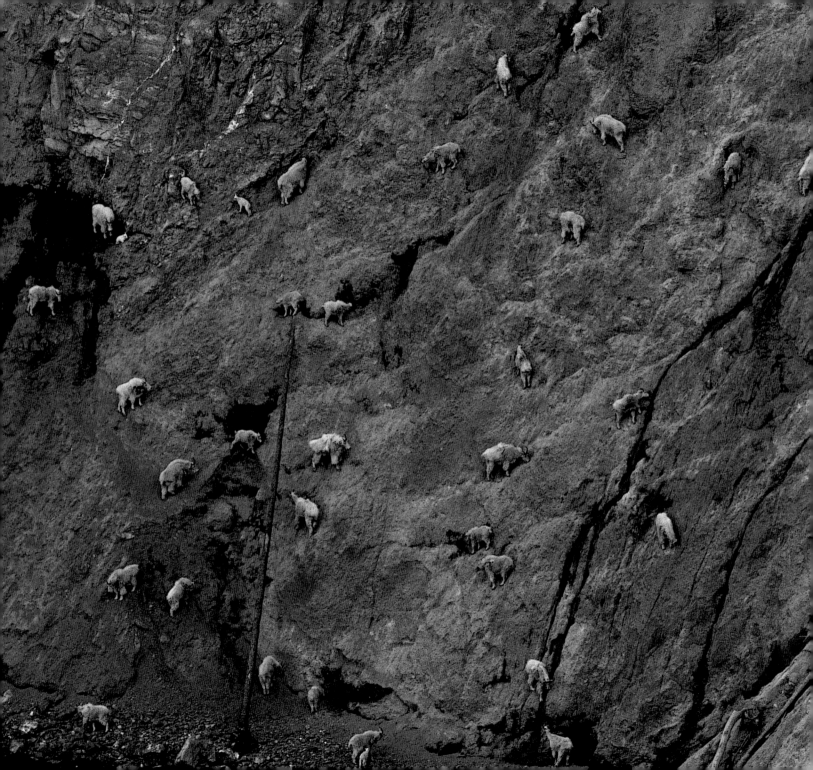

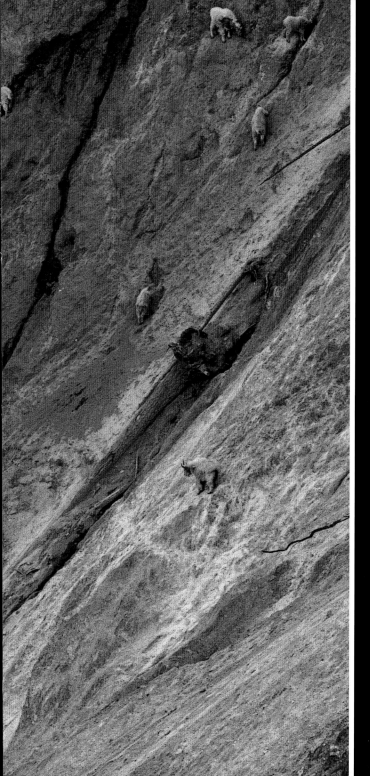

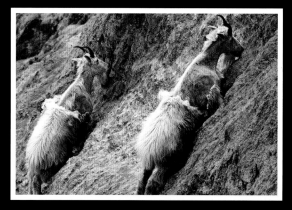

Walton Goat Lick on the Park's southeastern boundary. Goats congregate on these exposed, mineral-rich cliffs, traveling far from their usual home ranges in search of the natural minerals they crave. Black bears, elk, and deer can also be seen taking advantage of this resource.

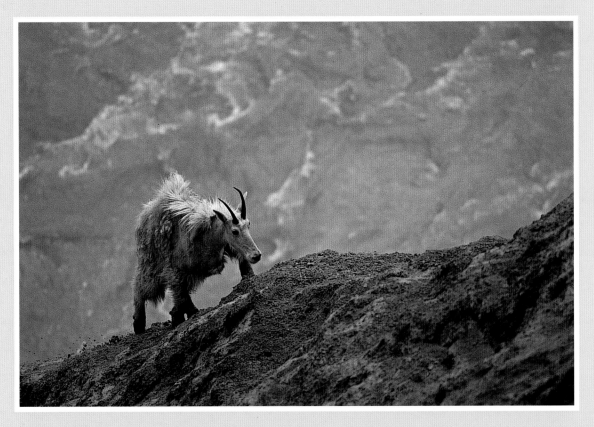

ABOVE: With the Middle Fork of the Flathead River rushing below, a goat carefully climbs the Walton Goat Lick.

FACING PAGE: The sodium, potassium, calcium, and magnesium found in this mineral deposit may help combat deficiencies acquired over the lean winter months, as well as help strengthen bones and thicken hair. Goats will lick seep areas for hours at a time, between bouts of resting and grazing in adjacent areas.

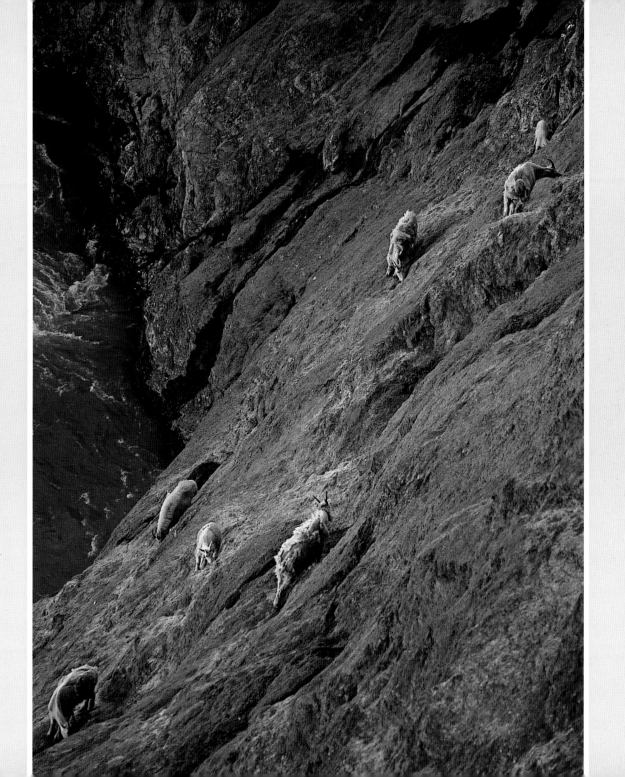

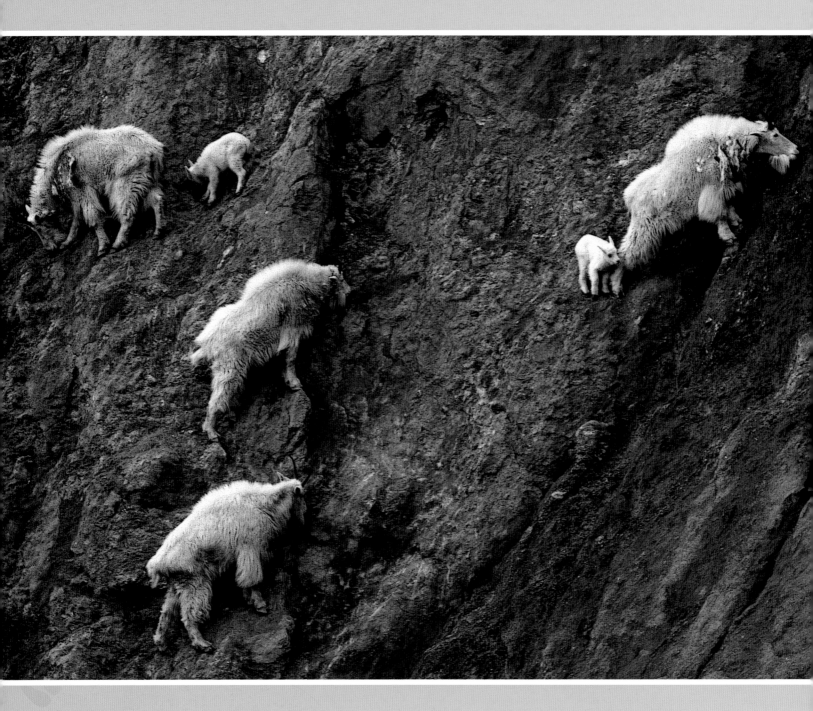

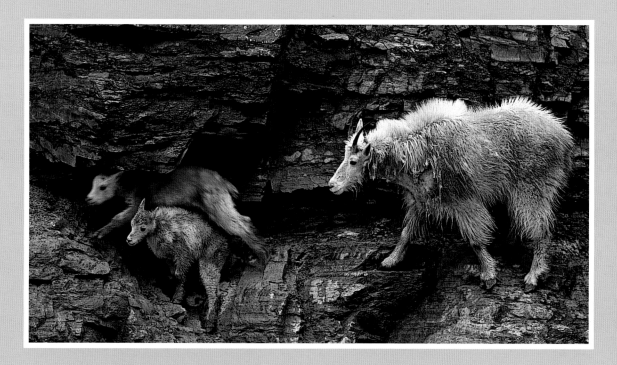

ABOVE: Young kids learn the migration route from their elders, who use old, established trails worn down over generations of use. The Walton Goat Lick is an excellent spot for Park tourists to watch these often-elusive creatures.

FACING PAGE: While they spend most of the year in separate, gender-related groups, billies mingle with nannies and kids at the goat lick. Adult males and females with young share relatively equal levels of dominance when on the lick, though males are subordinate to the more aggressive females when in their usual ranges.

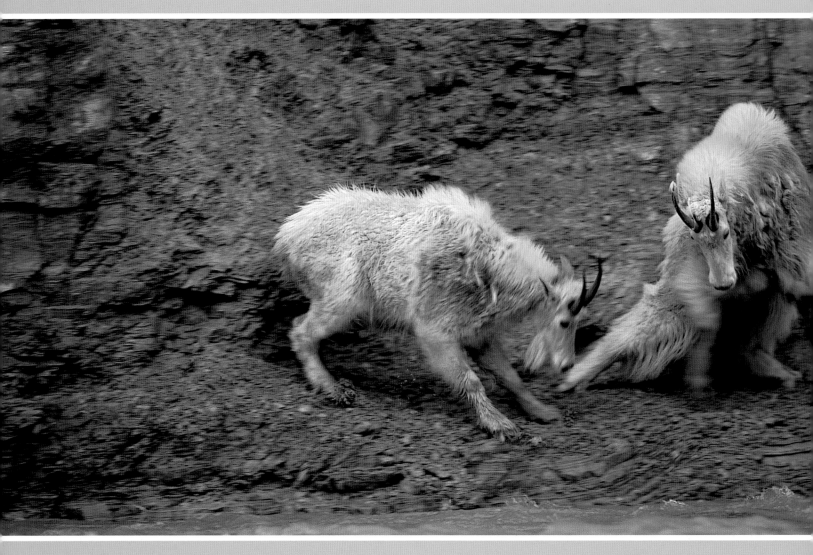

ABOVE: With such a high concentration of animals in one area, fights break out over the best licking spots. Unlike bighorn sheep, mountain goats possess comparatively small horns and fragile skulls and therefore do not spar by head-butting. Instead, they use their sharp, pointed horns to hook and jab at each others' hindquarters, an act that can result in serious injury.

FACING PAGE: Mineral deposits are so desirable that they entice goats from the safety of their craggy cliffs and drive them to swim the river. When in water or on flat ground, goats are far more vulnerable to predators such as mountain lions.

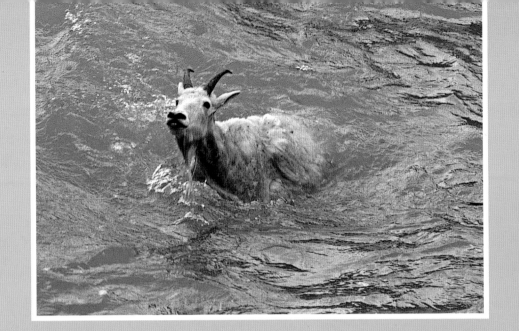

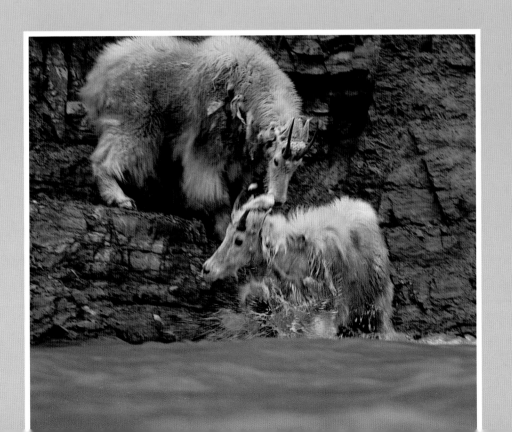

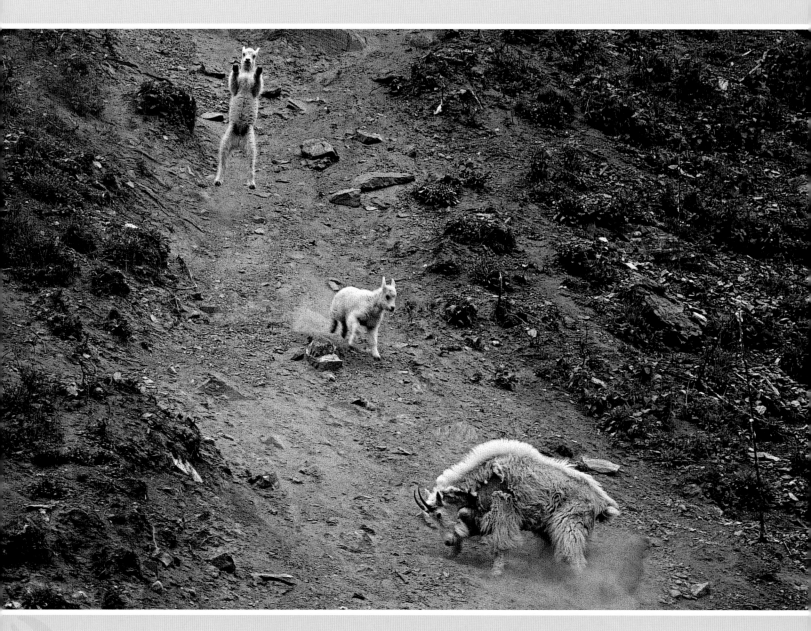

Sliding can be fun! Frisky individuals demonstrate play behavior,
which also shows off their health and fitness.

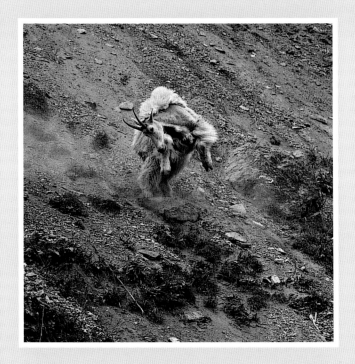

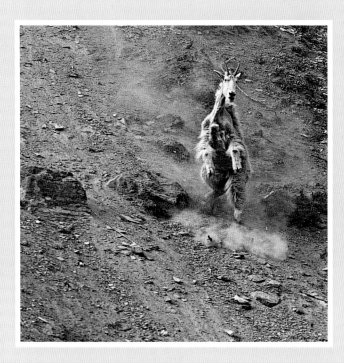

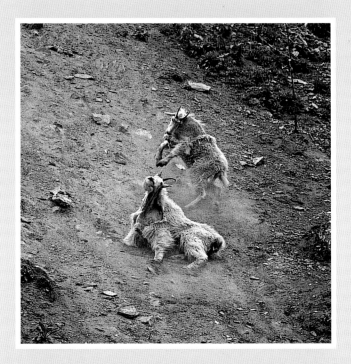

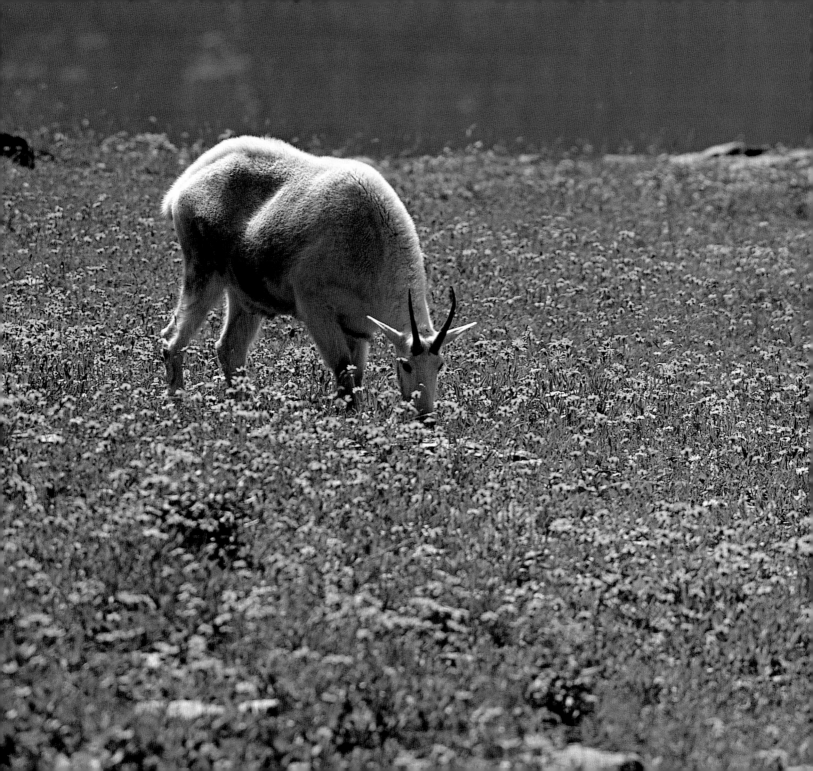

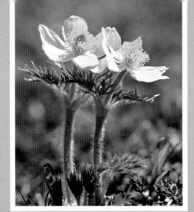

SUMMER

Summer is a time of plenty. The Park's sub-alpine meadows explode with color as the wildflowers rush to their vibrant crescendo. Elk, deer, bighorn sheep, and mountain goats flock to these lush grazing grounds, making the most of the warm weather. Ever vigilant, goats know they are more vulnerable to predators on flat ground, and groups tend to choose grazing areas with quick escape routes to their favored ledges and rocky precipices.

Nannies and kids congregate in loose nursery herds; group size varies from just a few individuals to twenty goats or more in areas of particular food abundance. Yearlings and two-year olds usually travel within these nursery groups until their third year, when they become mature adults and join their respective gender groups. Meanwhile, billies remain solitary or form small bachelor groups and live separately from the females for most of the year.

Mountain goats are known to be more aggressive than other ungulates. Nanny goats are highly competitive and will aggressively protect their kids, foraging areas, bedding sites, and personal space. Although nannies, kids, and yearlings spend most of their time apart from mature billies, if their paths do cross, females are consistently dominant over the males. Maintaining a rank of dominance is especially important when it comes to finding the best bedding sites and optimal foraging patches. Even in summer, such resources are in high demand in the Park's upper-altitude environments, and access to them is essential to the goats' survival. Indeed, the nanny's ornery reputation occasionally transcends species' boundaries, and observers have witnessed females attempting to bully even their bighorn sheep neighbors!

ABOVE: Western anemones open up to the summer sun.

LEFT: Feasting in a fragrant field of arnica.

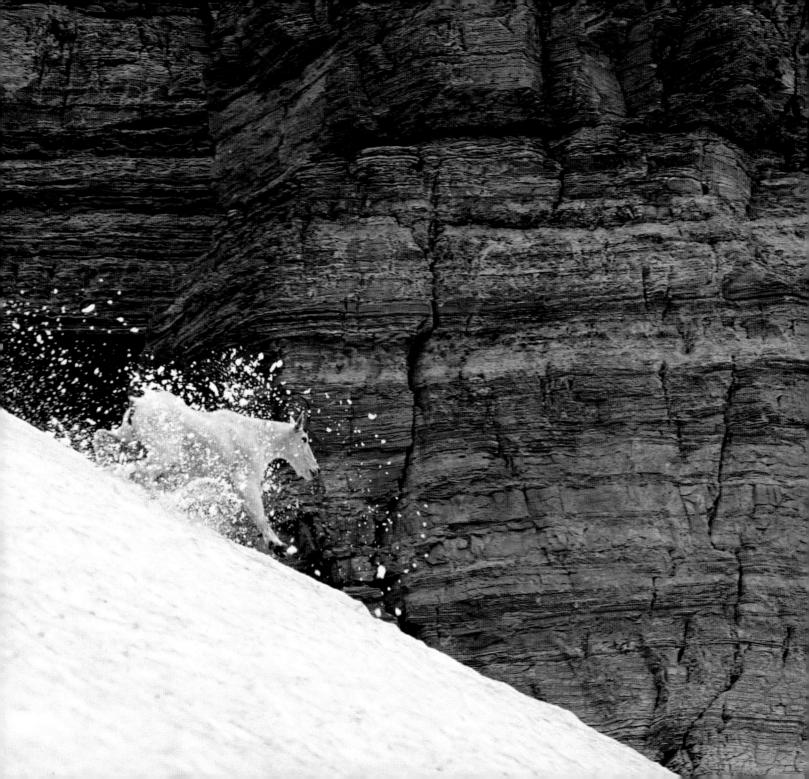

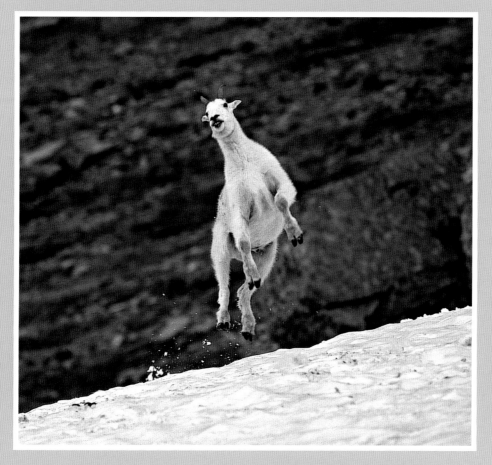

ABOVE: Airborne! A young billy goat shows off his best moves.

FACING PAGE: Many of Glacier's shaded snowfields persist throughout the summer. These melt-hardened banks are hard-packed and easier to travel across than fresh winter slopes.

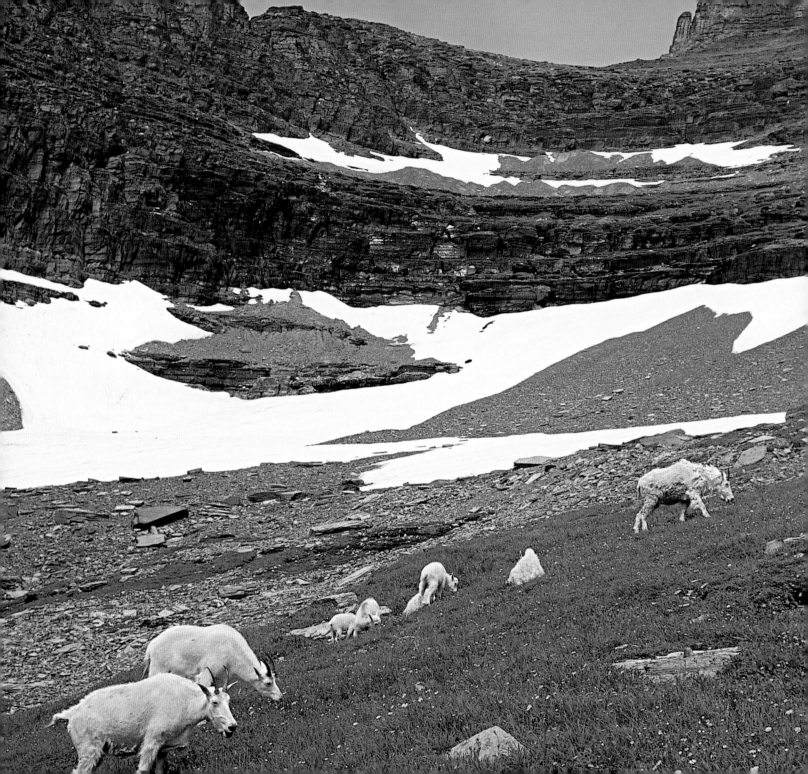

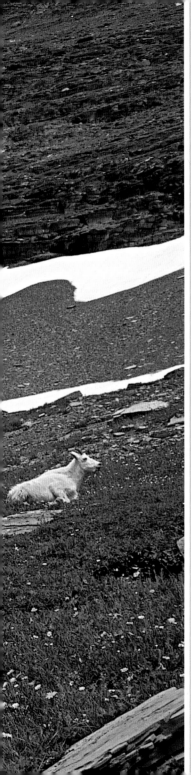

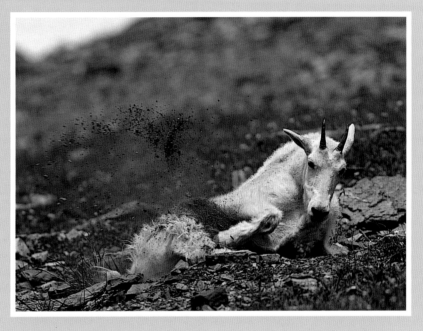

ABOVE: In the summer months goats commonly roll in wallows, covering themselves in mud or dust. This behavior probably helps them shed loose hair, and it may also help remove and deter parasitic insects.

LEFT: Some female nursery groups can reach more than twenty in number. Herds will spend as much time as they can grazing on lush alpine and sub-alpine vegetation.

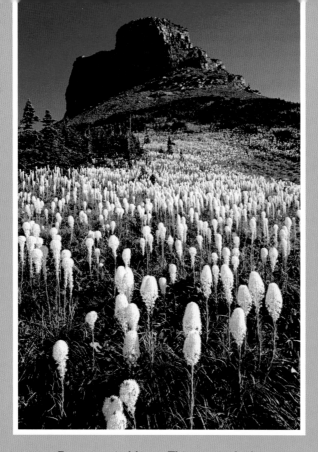

ABOVE: Beargrass in bloom. This unusual white-topped plant is a member of the lily family. It tends to bloom in five- to seven-year cycles, and fully blooming stalks can grow to nearly six feet in height.

RIGHT: Two billies forage on beargrass buds. Males often form small bachelor groups during certain times of the year, especially the summer, before separating for the breeding season.

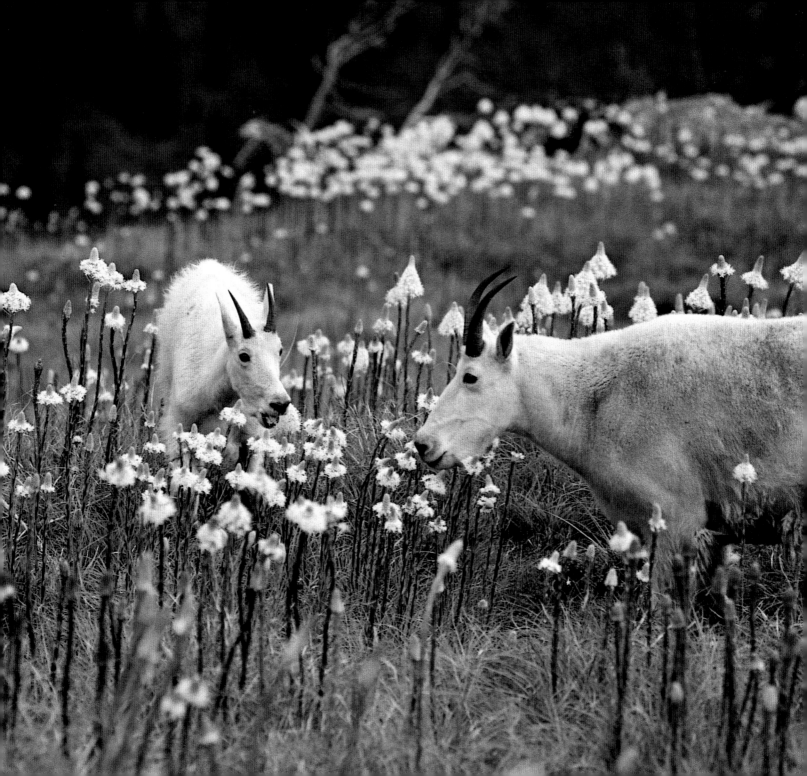

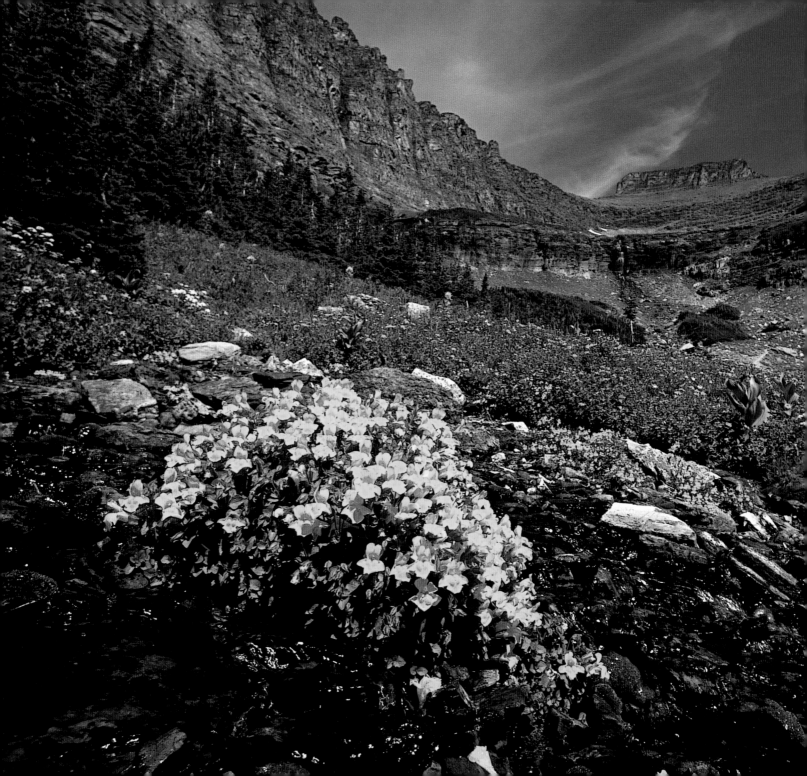

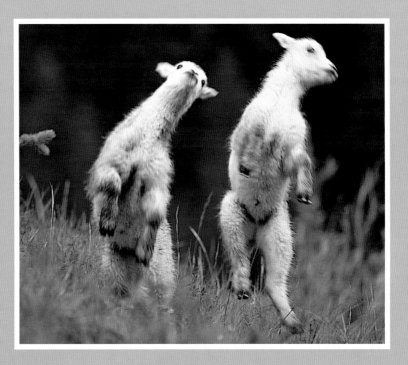

ABOVE: It's good to be a kid!

LEFT: Vibrant monkeyflowers flourish along alpine seeps and riparian corridors. Their brightly colored petals lure all manner of bees and butterflies, which are essential to their pollination.

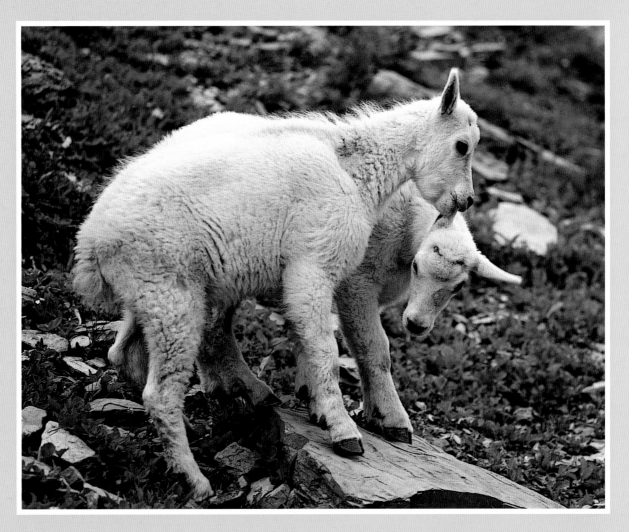

Playing helps kids to socialize and also increases their strength and agility. Navigating through these nursery groups teaches young goats about the social dynamics within a herd. Dominant kids are at the top of their own little hierarchies.

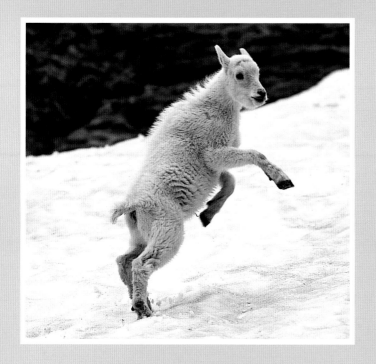

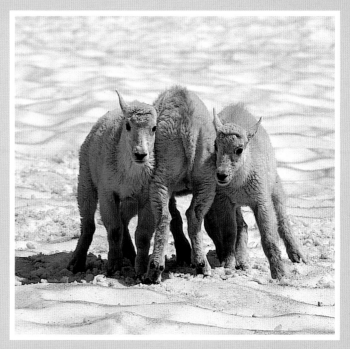

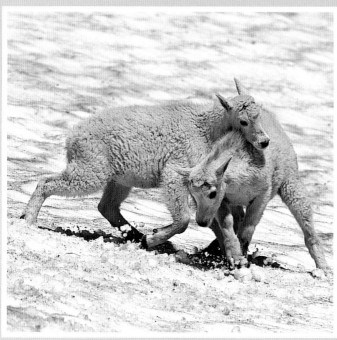

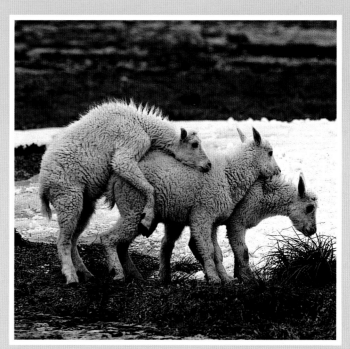

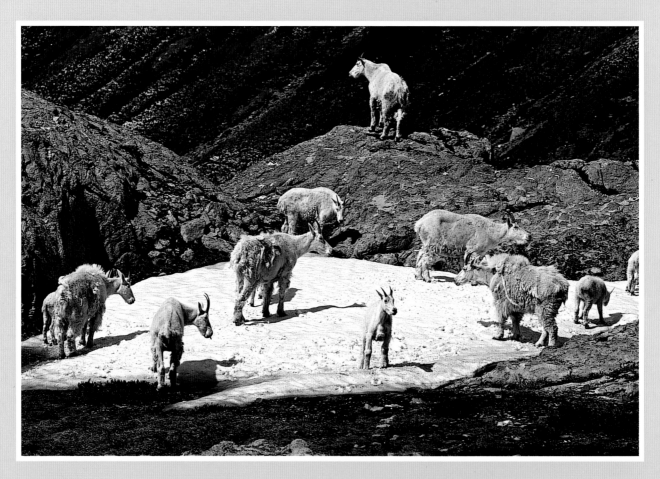

ABOVE: Errant snowfields shaded by towering peaks provide cool resting areas and a break from the summer heat.

FACING PAGE: Sexton Glacier looms over a talus slope. Like all of the Park's glaciers, Sexton continues to recede with each passing year.

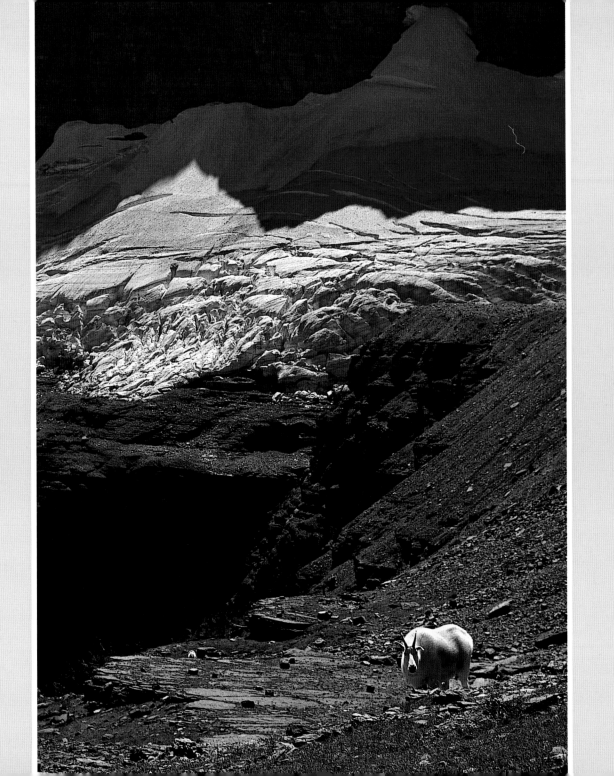

The bustle and buzz of summer winds down with the coming of autumn's brisk breezes. Aspen and cottonwood leaves glow and then drop from the branches, and Glacier's slopes march from green to golden with the brilliant turning of larch needles. Goats and the other animals that over-winter in the Park spend the fall months eating as much as they can, gaining weight and growing back their thick winter coats. A new energy sweeps the hills with the coming of another breeding season.

Mountain goats typically begin their rut in late October or early November. Females come into estrus at the same time, ensuring synchronized birthing the following spring and the relative safety of having kids at the same time. Throughout the rut, billies announce their intentions with different scent-marking techniques. Digging, urinating, and wallowing in rutting pits helps to increase their natural odor; brushing their heads against vegetation helps to disperse the musky scent secretions that leak from swollen, crescent-shaped glands at the bases of their horns.

Given the nanny's legendary temper, a courting billy must approach a potential mate with great caution. Only if she is in estrus will she tolerate his presence. Even then, a male must approach in a slow, submissive, crouching position, ever wary of his mate. Once accepted, a male may defend his partner from competitors, but this temporary pairing ends with the close of the breeding season. Pairs soon go their separate ways and prepare for the onset of winter.

FALL

ABOVE: A small band on the move.

RIGHT: Another summer fades into fall on the Highline Trail in the heart of the Park. As tourist season slows, this popular hiking trail is quietly reclaimed by a herd of grazing nannies.

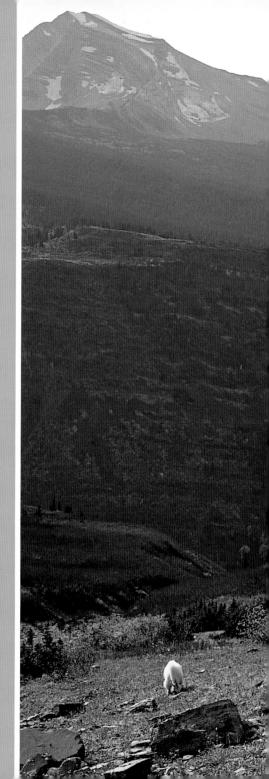

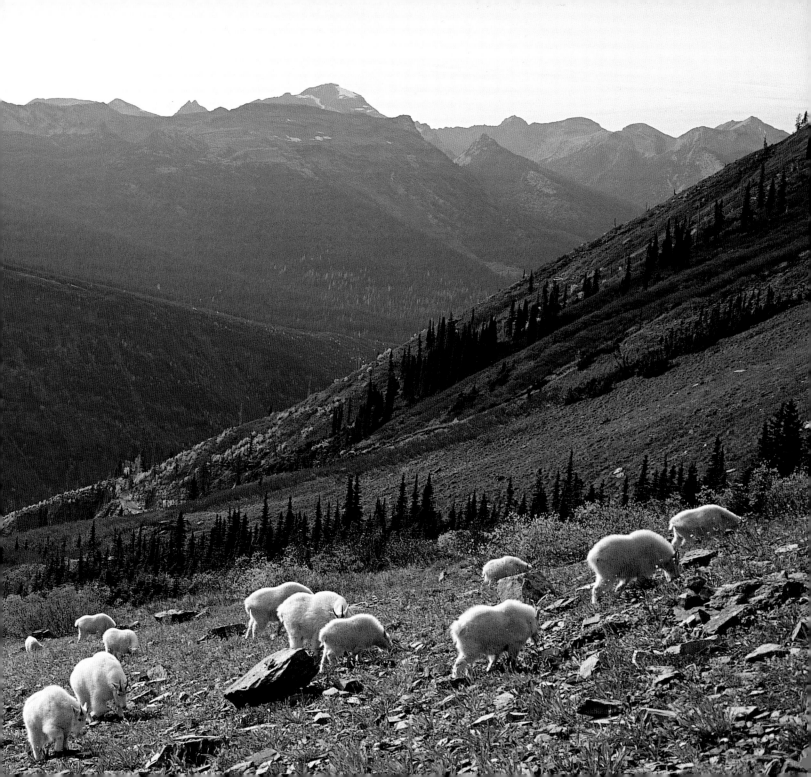

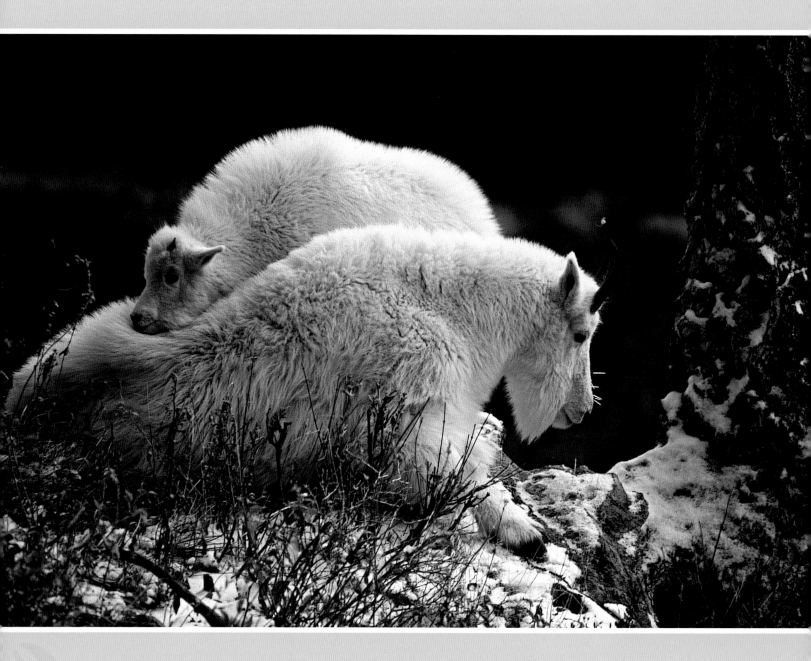

FACING PAGE: A young kid nuzzles its mother. The quills protruding from her nose indicate a recent tangle with a porcupine.

BELOW: Goats and porcupines are among nature's most salt-loving animals. Both have been known to frequent human campsites in search of urine-stained soil, and goats have been caught stealing sweaty T-shirts left out to dry. Although we can only speculate as to what circumstances may have led to this nanny's mishap, it is possible that she ran into the quill-bearer at some such human mineral deposit.

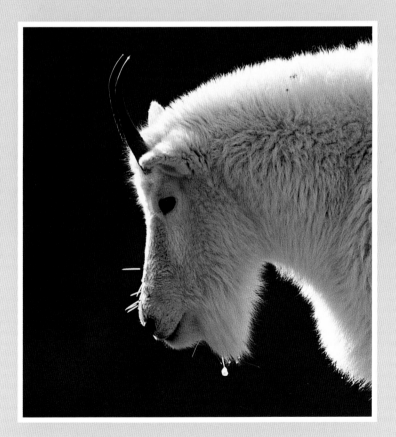

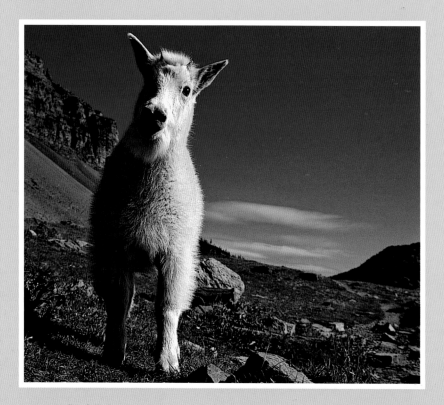

ABOVE: By fall this kid has grown all the layers of its soft, full coat—and sprouted two small horns.

RIGHT: Glassy Lake McDonald flanked by clouds, as viewed from Apgar Lookout. Larch trees color the foreground of this scene; their deciduous needles paint the hillsides gold before falling to the forest floor.

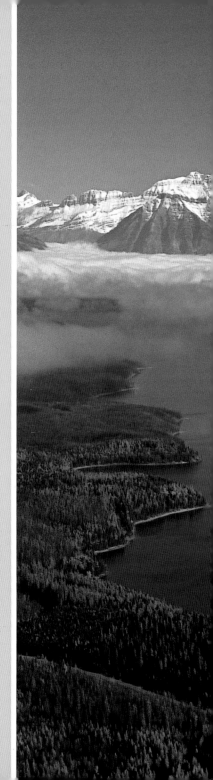

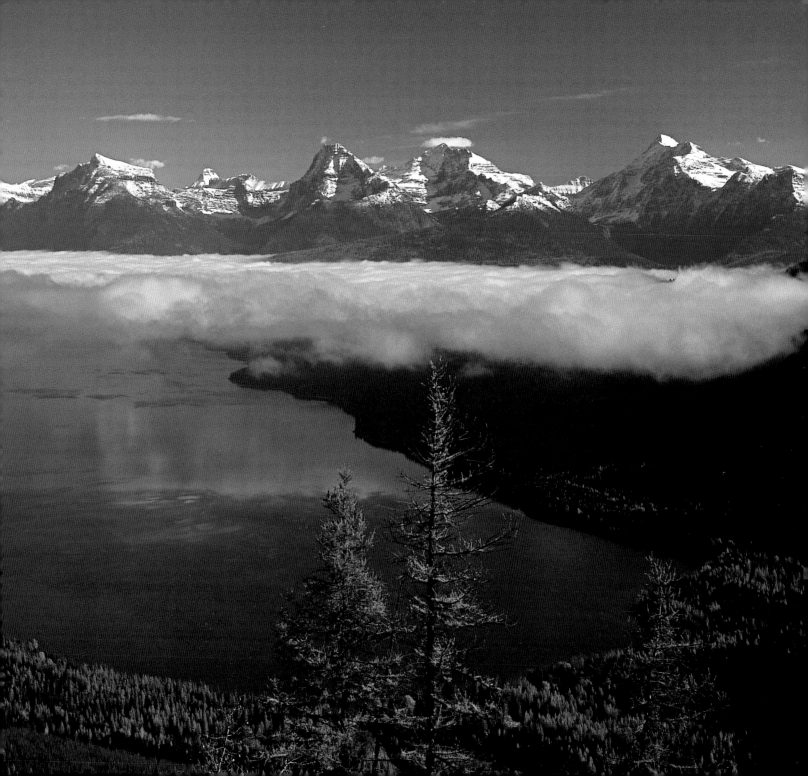

RIGHT: Changing willows turn the woods a fiery yellow.

BELOW: As leaves wilt and turn brown, they lose much of their nutritional value. Still, mountain goats munch on whatever vegetation is available in order to build up their fat stores for the winter.

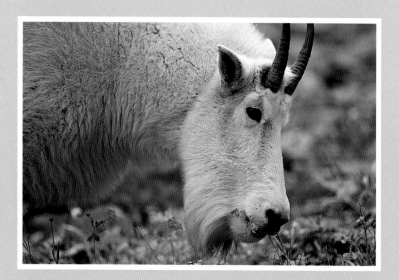

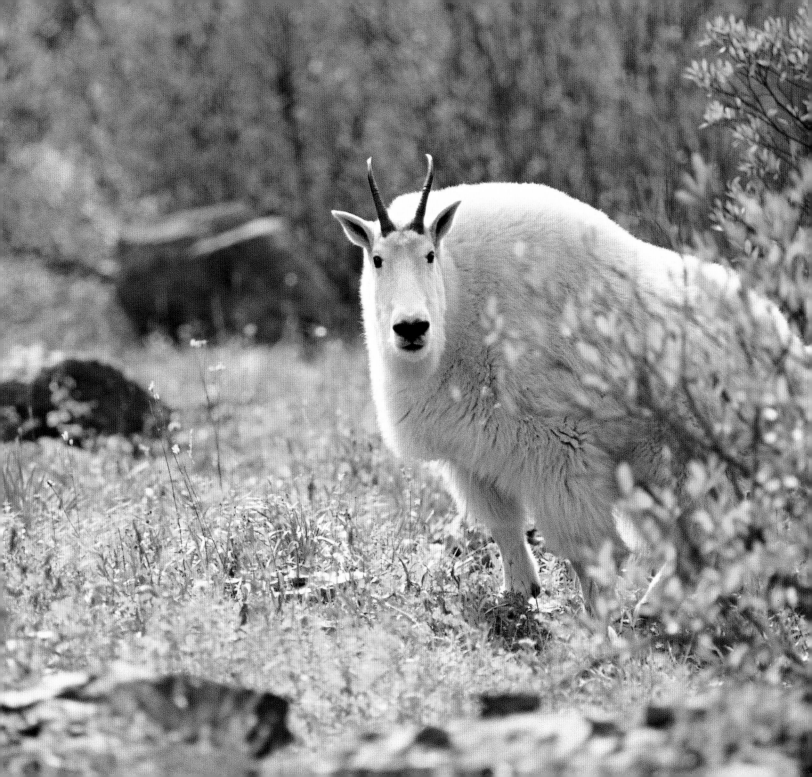

Low-hanging clouds roll across the valley. Soon the quiet white of winter will blanket the high country.

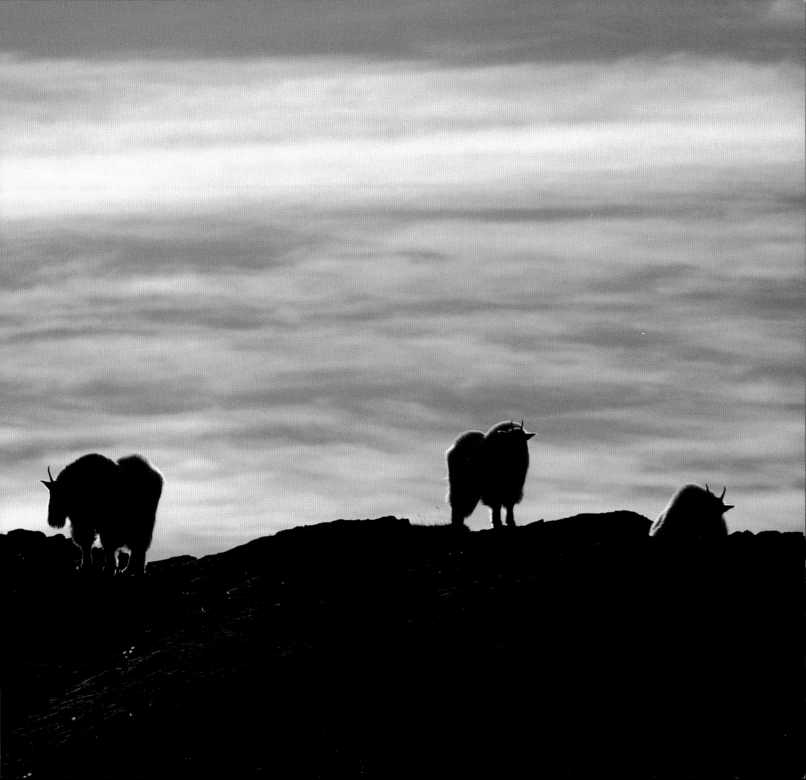

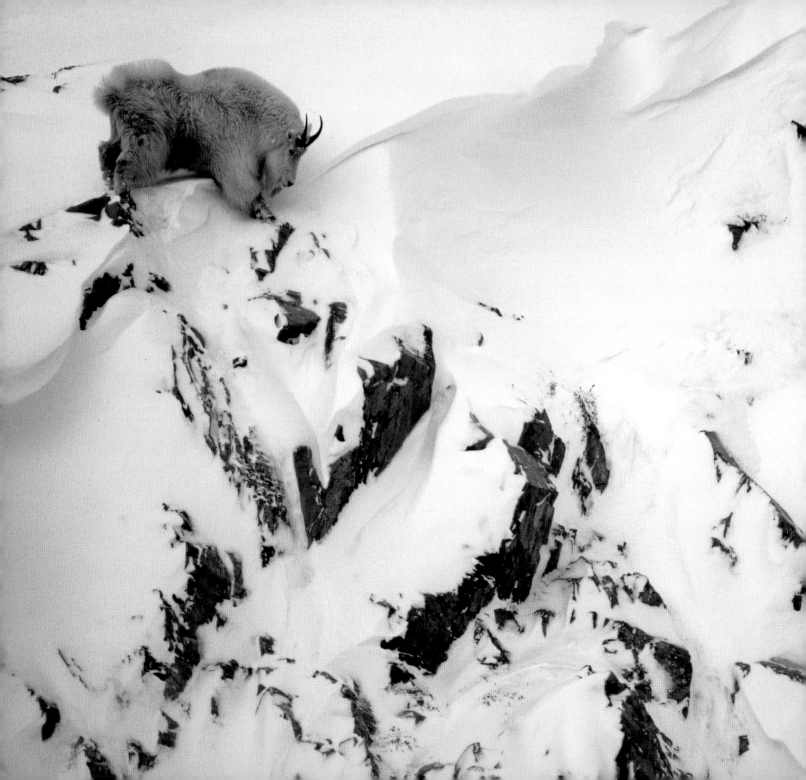

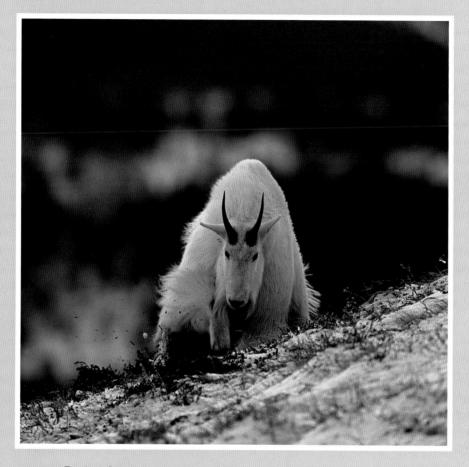

ABOVE: During the mating season in fall, called the rut, males accentuate their presence by digging shallow pits, where they urinate and then kick dirt up over their hindquarters and abdomen, thus magnifying their natural scent.

FACING PAGE: Billy goats become especially active in late October with the start of the breeding season. Males separate from bachelor groups and begin to travel more extensively in search of females in estrus.

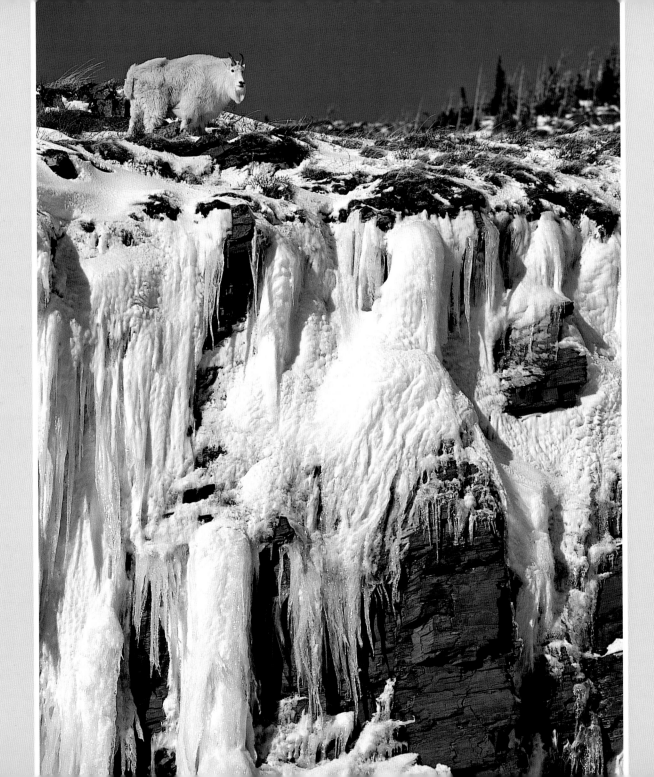

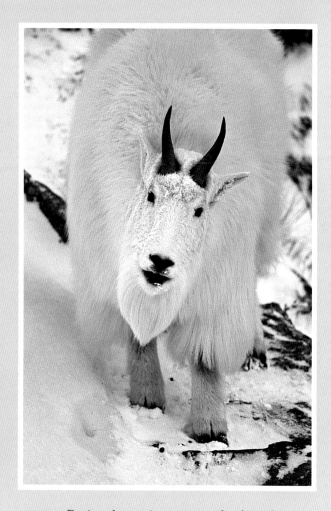

ABOVE: During the rutting season, glands at the base of the billy's horns visibly swell, emitting a musky oil.

FACING PAGE: In November 2006 a record rainfall washed over Glacier National Park. In its wake, the sudden rain left icicles massive enough to rival frozen waterfalls.

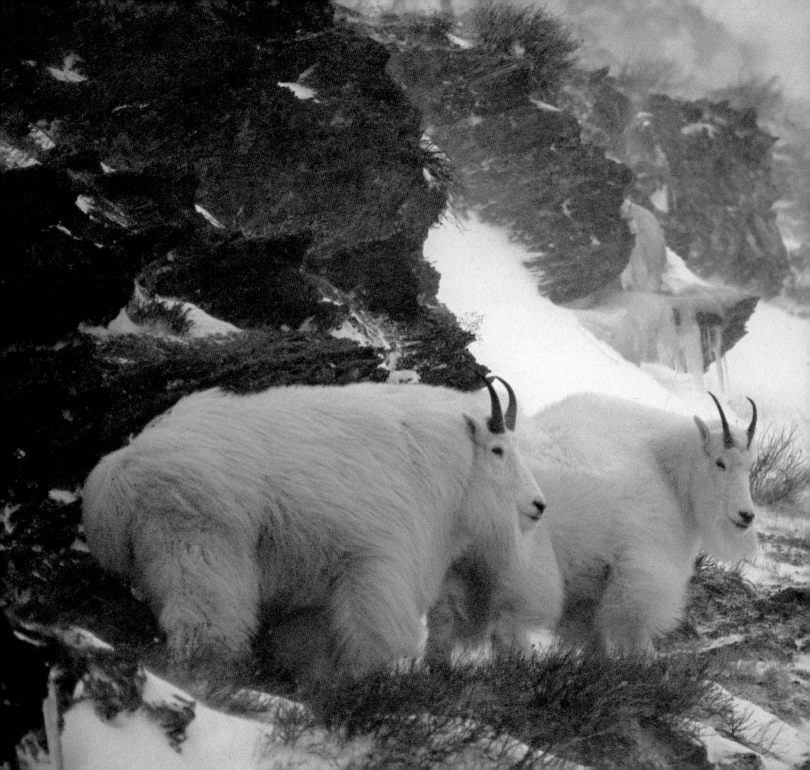

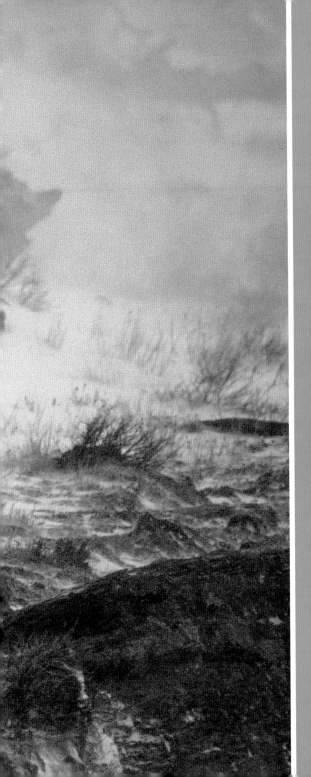

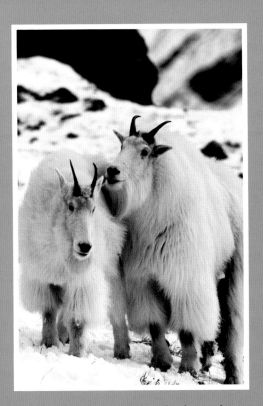

ABOVE: Once accepted, males keep close to their mates.

LEFT: A billy tentatively approaches an available nanny as a blizzard blows in.

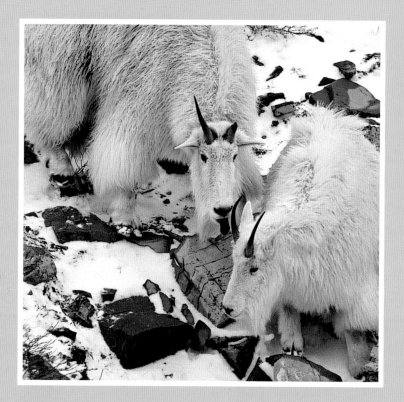

ABOVE: When near females in estrus, billies often flick their tongues. It is believed this is a way to communicate interest in a particular female.

RIGHT: After courtship and mating are over, males and females soon separate. However, this particular pair remained together through the end of the breeding season.

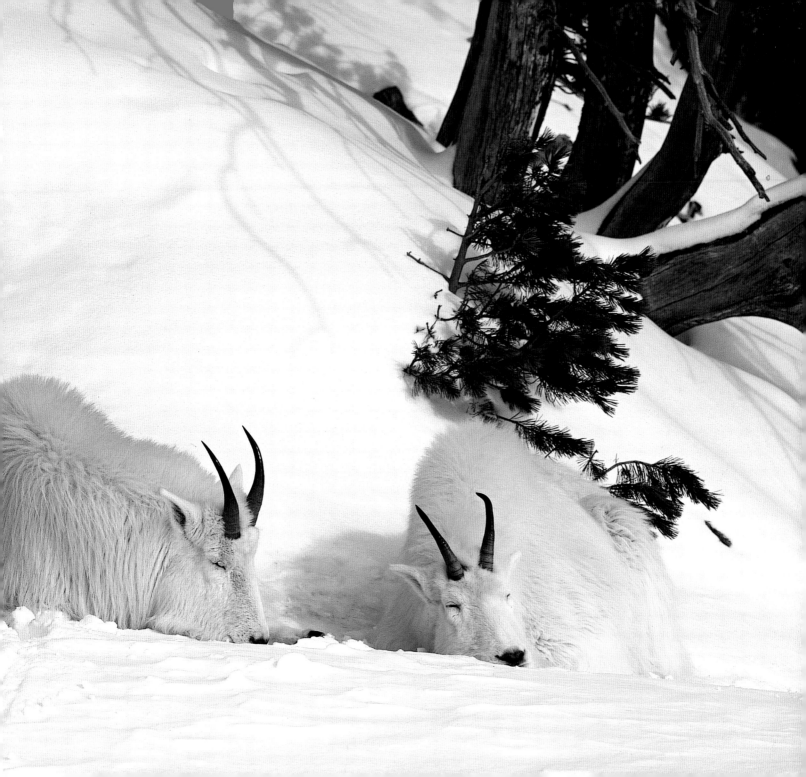

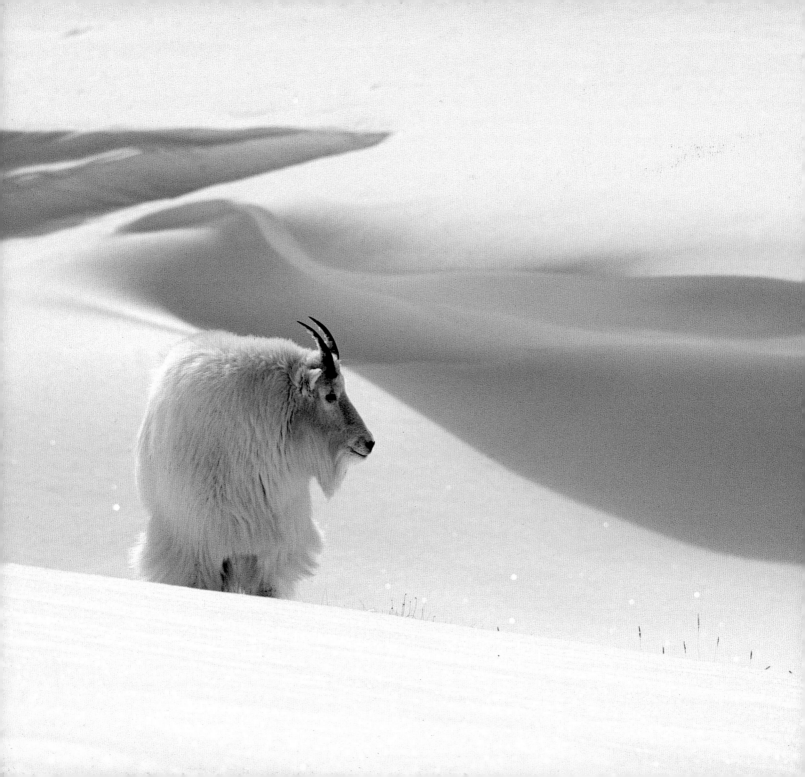

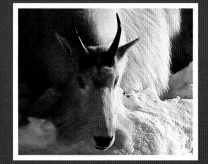

WINTER

Winter is the harshest time of year for mountain-dwelling ungulates. Deep snow and freezing temperatures make finding food a constant challenge. When the weather gets too severe, mountain goats may descend from their cliffs and spend time on more level ground, though even then they tend to remain above treeline.

Though the winter may be ruthless, mountain goats are used to inhospitable living conditions. Their thick pelage (coat) helps to insulate them from Glacier's extreme cold and brutal winds. By late November the long, coarse guard hairs and underlying dense fur of their shaggy winter coats have filled in completely and will prevent snow and moisture from seeping down to their skin.

Wind-blown slopes offer easier access to exposed grasses. When the snow is deep, goats kick it aside, digging down to the ground to graze. When it is altogether too deep, they may shift their attention to browsing on the twigs and needles of spruce and alpine fir. Fat reserves provide a cushion in the lean months, but starvation, particularly of kids, is still a common cause of death by late winter. Goats are also more vulnerable to predators in this hunger-weakened state.

Avalanches are another concern, particularly when snow conditions change with the first thaws and re-freezes of early spring. As sure-footed as mountain goats are, they have virtually no defenses against these fast-moving, overwhelming masses of snow, which can descend in an instant, burying whole groups at a time. Amazingly, however, every year most goats make it through this bitter season, a true testament to their hardy, resilient nature. Their reward comes in another sweet spring and the beginning of a new generation.

ABOVE: A billy gets reacquainted with the snow.

LEFT: With the end of the breeding season, billies again set off on their own, returning to the shadowy veils of their snow-covered world.

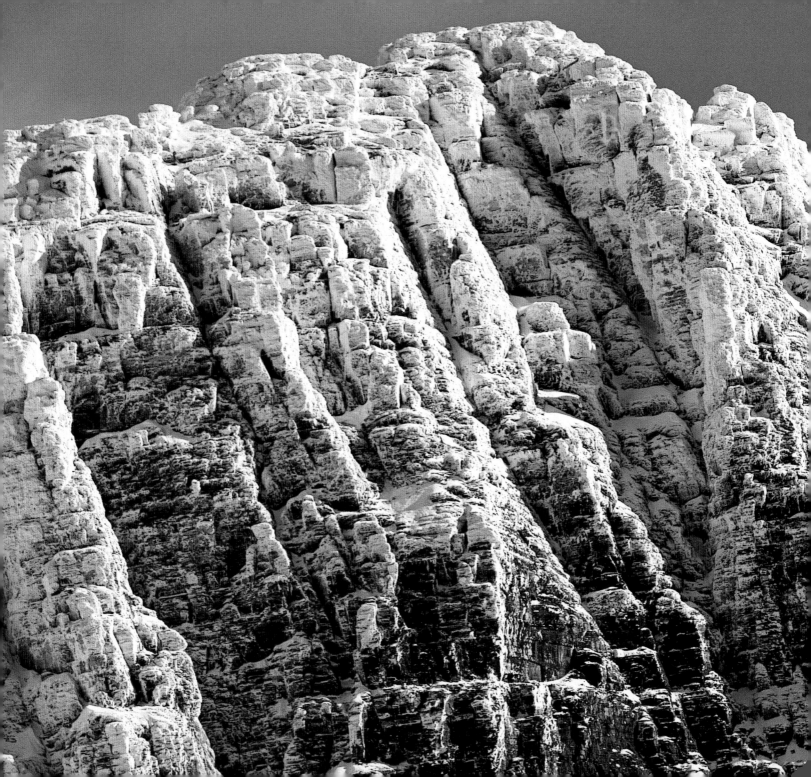

LEFT: The frozen Garden Wall in central Glacier National Park. This prominent narrow ridge, or arête (French for "fishbone"), was formed when two separate glaciers scoured either side of the wall, whittling it down to this high and slender ridge.

BELOW: The evening sun slips away, stealing with it the last bit of warmth. Many long, cold nights await.

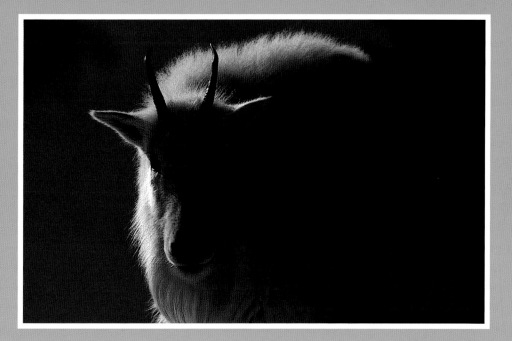

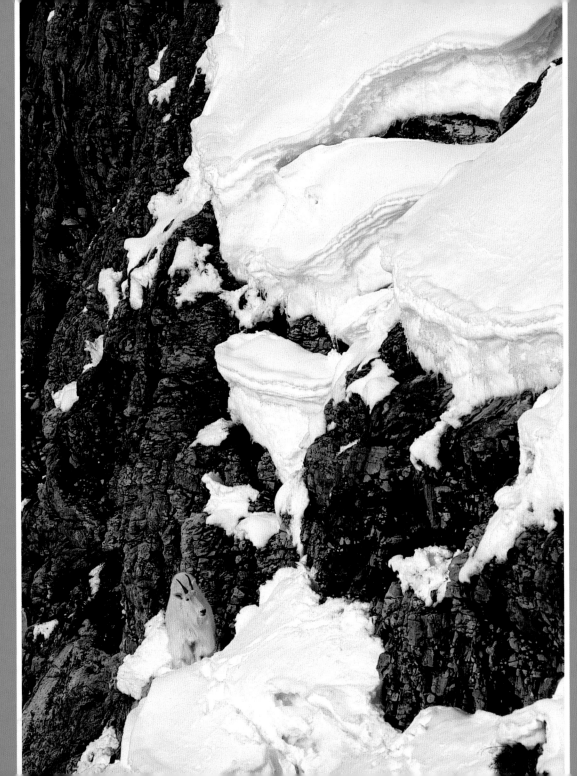

Glacier's steep slopes and ridges provide the perfect conditions for avalanches. Factors such as strong wind—which causes snow to accumulate in unstable drifts—and solar radiation—which softens snow before it re-freezes at night—can lead to dangerous, uneven snowpack conditions. For animals that spend their time climbing such terrain, winter can be a treacherous time of year.

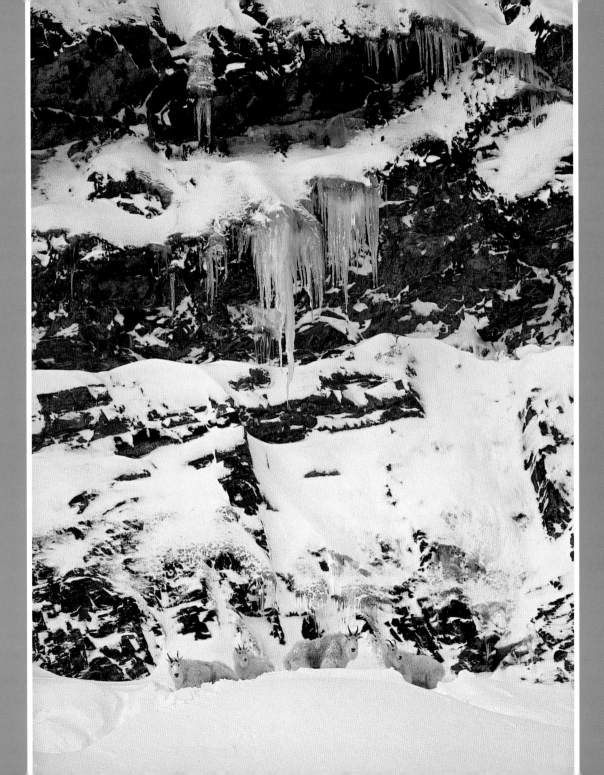

A small group waits out another blizzard from the safety of level ground.

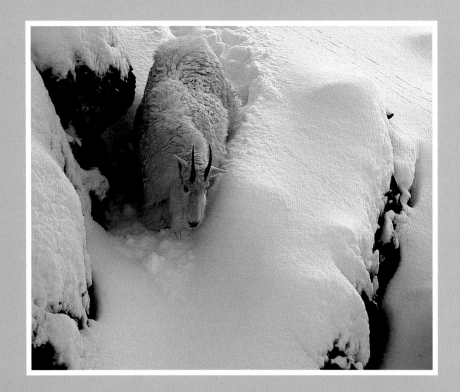

LEFT: Though deep snow may cover the way, the routes are still familiar, and mountain goats continue to travel relatively freely throughout the winter.

FACING PAGE: Amid a fog of windblown snow, these animals appear like ghosts. They are so suited to their environment that at times they seem nearly invisible, swallowed up by it.

RIGHT: Sometimes all the survival skills in the world cannot prevent death. Winter's harsh conditions are far more threatening than any predator, and each year goats succumb to avalanches and starvation.

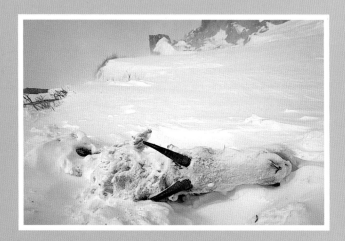

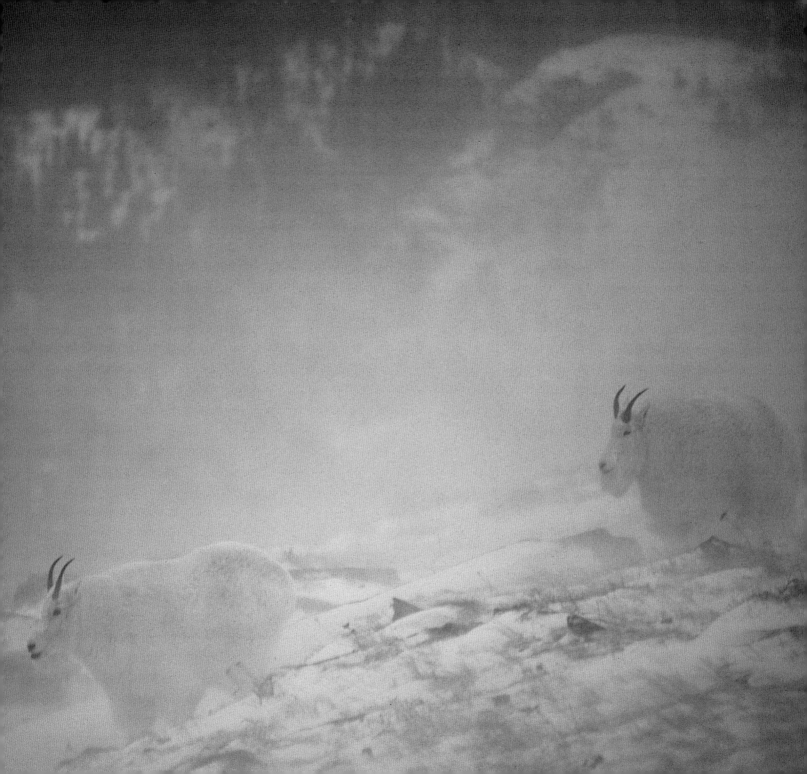

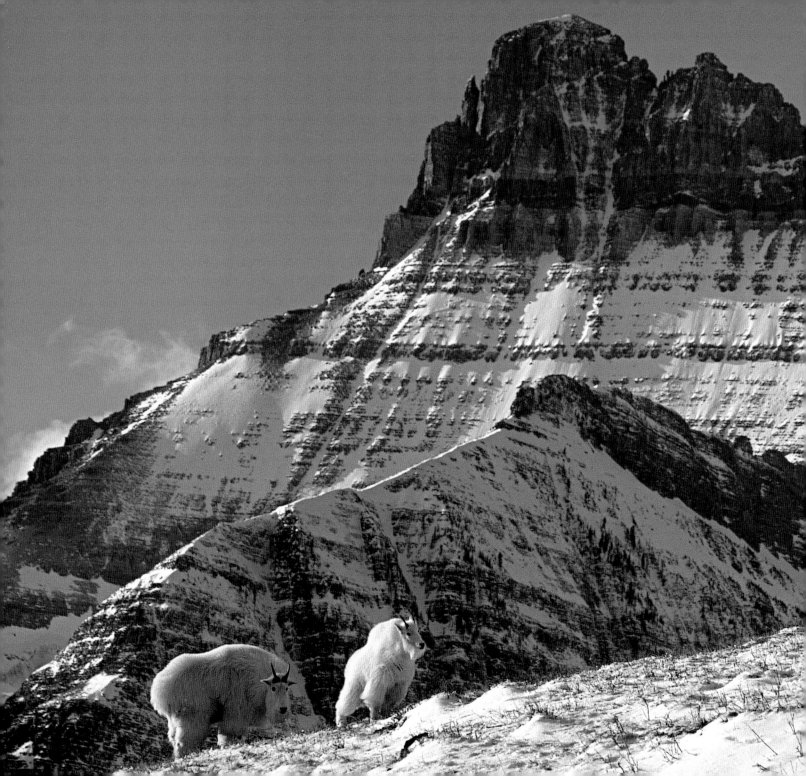

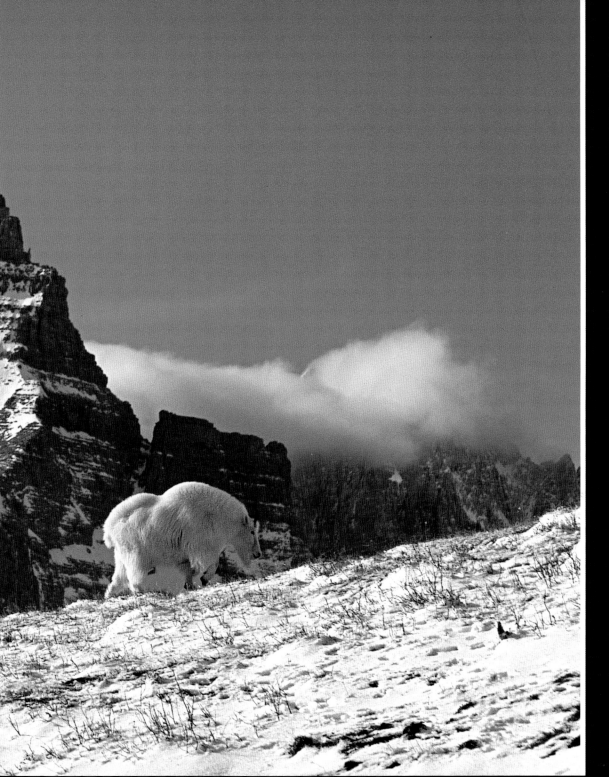

Individuals forage on a windswept slope under the generous gaze of Mount Wilbur in the Many Glacier region of the Park. Exposed areas like this are highly desirable feeding grounds in winter because the animals do not have to spend energy digging through deep snow to reach buried vegetation.

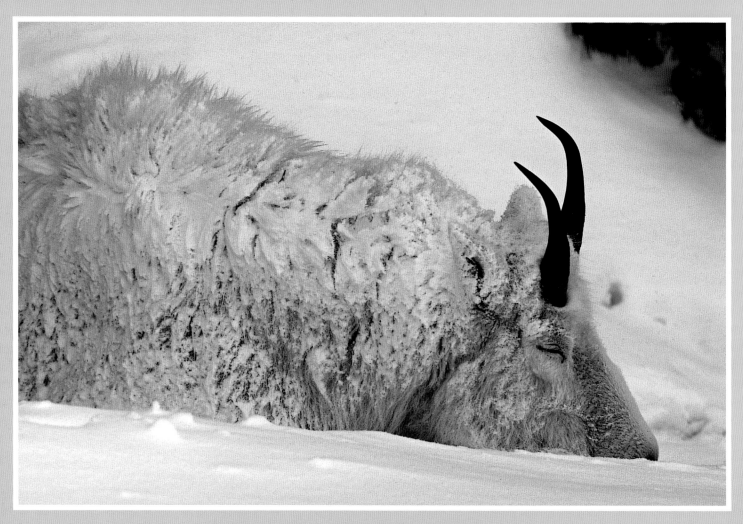

Asleep in the snow. A mountain goat's thick coat provides excellent insulation by holding body heat in and keeping wind and melted snow from soaking down to its skin.

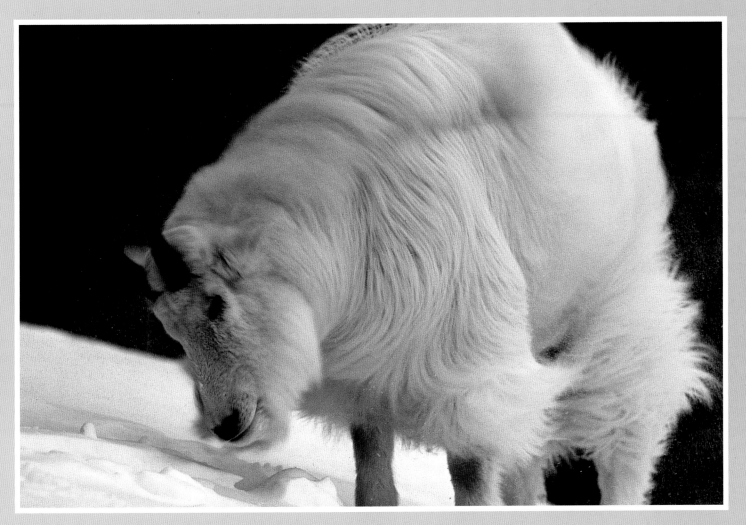

A quick shake is all that is needed!

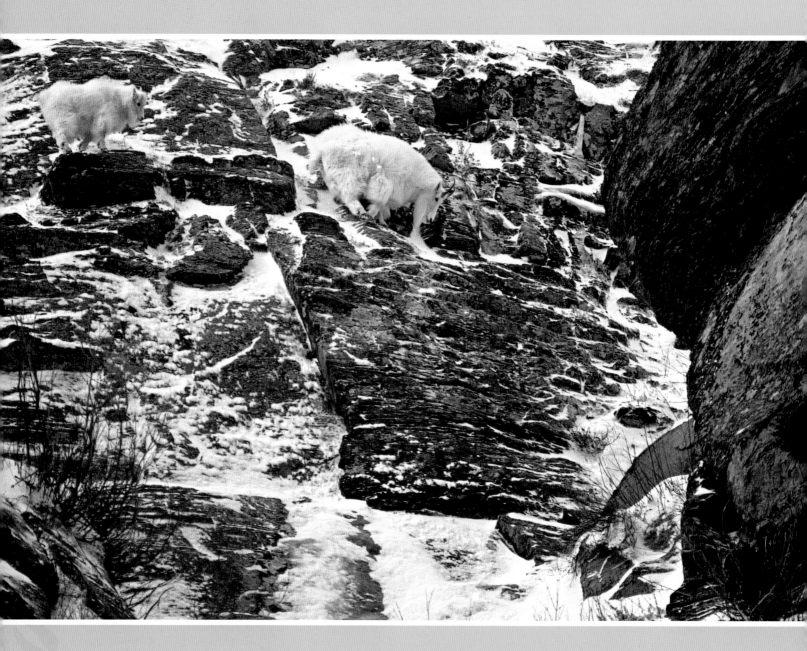

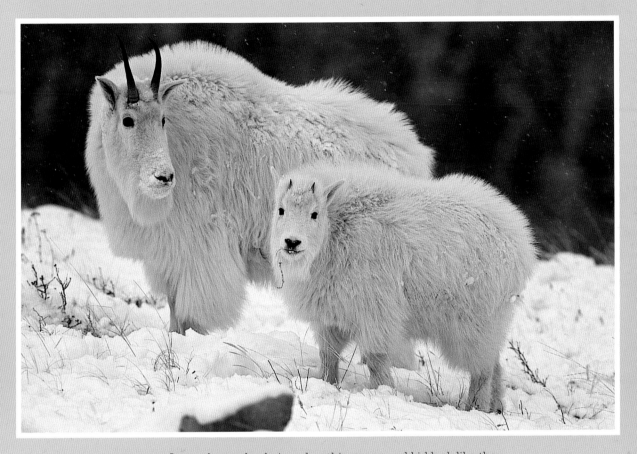

ABOVE: Long, shaggy leg hair makes this nanny and kid look like they are wearing billowing pantaloons. Males, females, and kids alike all possess the iconic, beard-like crop of fluffy jaw and chin hair.

FACING PAGE: During the winter months when food is scarce, goats can only hope to maintain, not increase, their body weight. With luck, their fat reserves will be high enough to get them through this lean season.

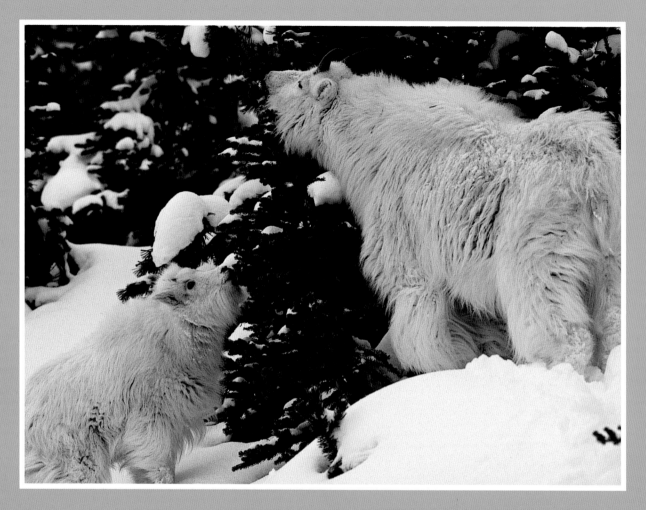

ABOVE: When snow accumulates to great depths and the ground becomes too difficult to reach, goats and other ungulates turn to browsing on shrubs and conifer needles. Here a nanny and her kid nibble on Engelmann spruce branches.

FACING PAGE: By kicking up snow with its forelegs, this goat slowly digs down to bare ground in search of withered vegetation.

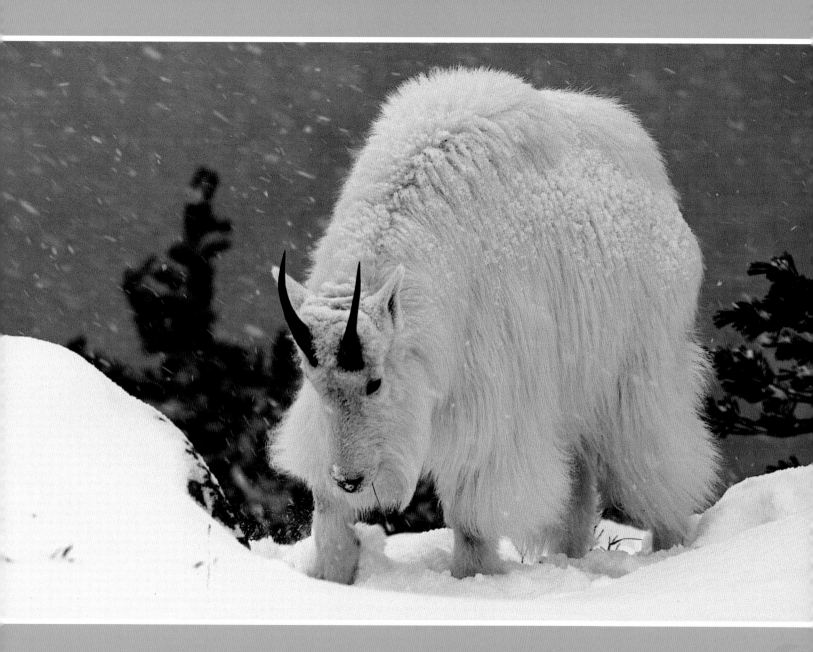

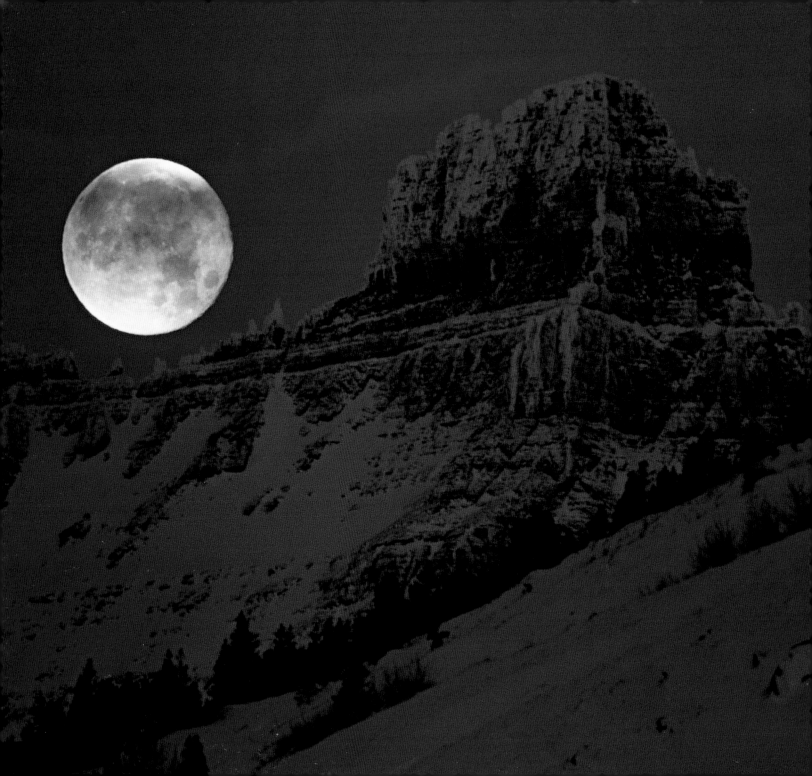

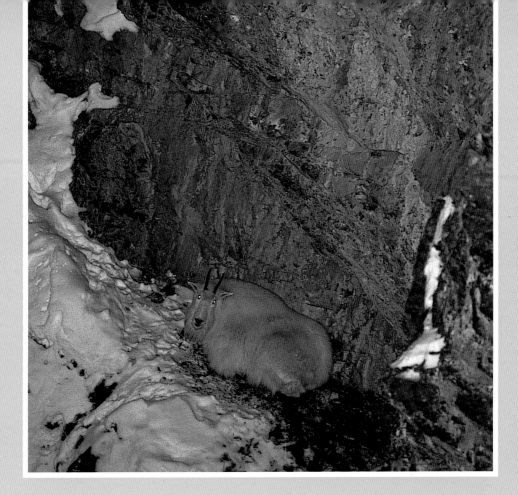

ABOVE: Mountain goats bed down for the night in secure, sheltered resting places safe from the elements. These rock ledges, caves, and cubbies protect their occupants from extreme wind gusts, avalanches, and potential predators.

FACING PAGE: A perfect full moon descends toward Ptarmigan Wall.

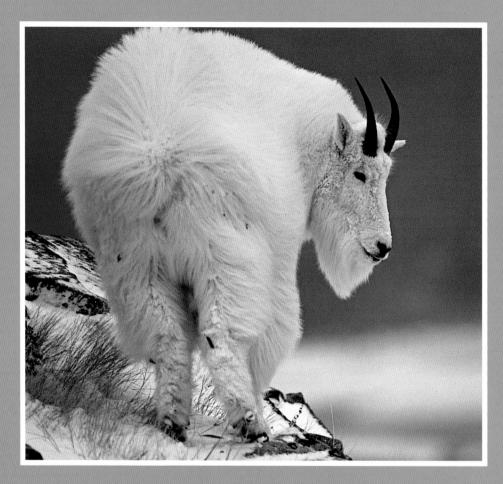

ABOVE: Despite the harshness of their chosen environment, mountain goats continue to thrive in Glacier National Park, one of the last places on the planet where they are completely protected. It is with grit and grace that they live their wild lives, confidently climbing toward places others rarely visit.

FACING PAGE: Morning blush over Mount Wilbur, and the glory of another day.

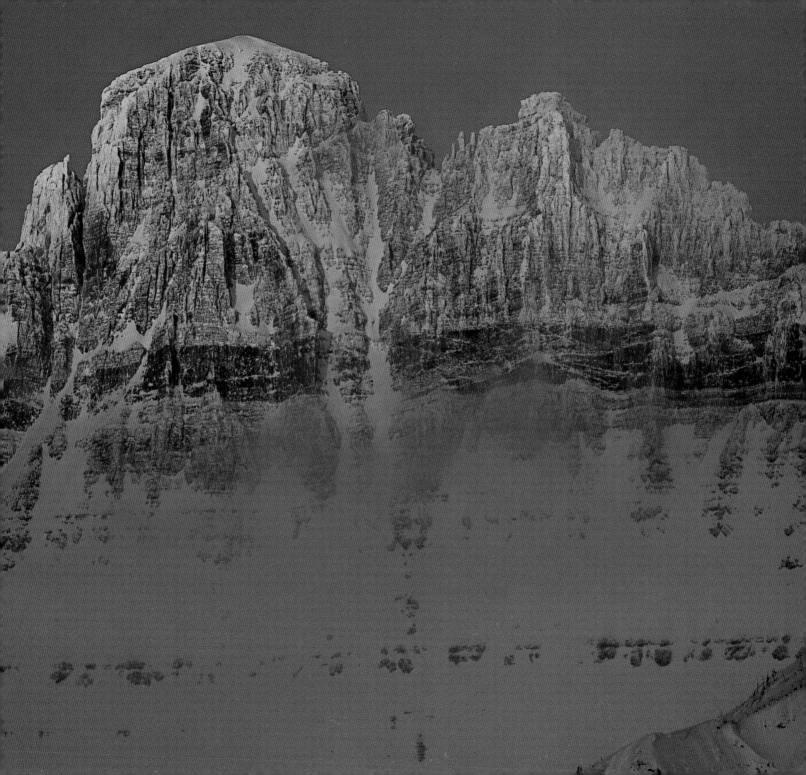

Sumio Harada was born in Japan. He studied biology at the Tokyo University of Agriculture. His research on the behavior of the Japanese serow, a close relative of the mountain goat, led to his wildlife photography career.

Between 1987 and 1989, Sumio spent eighteen months in the Rocky Mountains of Canada and the United States photographing mountain goats. These photographs earned him the Anima Award, given to a single distinguished wildlife photographer each year in Japan.

Sumio returned to the Rocky Mountains with his wife and daughter several times, sometimes living in their van, to continue photographing mountain goats. He and his family moved to the United States in 1994, and since then he has spent much of his time in the Rocky Mountains, particularly in and near Glacier National Park.

His images have been published in *National Geographic, National Wildlife, Ranger Rick, Canadian Wildlife, GEO* (Germany), *Montana Magazine,* and in many Japanese magazines and books.

Sumio lives near West Glacier, Montana, with his wife, Kumi, and daughter, Moyu.

To view more of Sumio's photographs, visit www.photorocky.com.